Sketching

MADE EASY

HELEN DOUGLAS~COOPER

CRESCENT BOOKS
NEW YORK • AVENEL

This 1995 edition published by Crescent Books,
distributed by Random House Value Publishing Inc,
40 Engelhard Avenue, Avenel, New Jersey 07001

Random House
New York • Toronto • London • Sydney • Auckland

ISBN: 0-517-14297-X

Produced by Haldane Mason, London

Acknowledgments
Art Direction: Ron Samuels
Editor: Miranda Fellows
Design: Paul Cooper
Photography: Joff Lee

All illustrations by Stephen Dew except for Projects 10 and 12,
which are by John Palmer.

Contents

Introduction

To sketch well, you need to hone your observation skills, learning how to look at and record the world around you. A good knowledge of the best drawing materials to use in this endeavor is essential, too. Choose your materials with both their expressive potential and their limitations in mind, because this will allow you to record your observations in an appropriate way, depending on whether you want to achieve accurate representation, a drawing that reflects the mood evoked by the subject, information for use in paintings, or a quick, expressive, spontaneous sketch produced for the sheer pleasure of it.

In some ways it is easy to get started with sketching: you just need to acquire a minimum of materials and get going. However, it will be much more enjoyable and satisfying if you know a little about the different techniques and ways of rendering a subject, and how to set about looking at the subject you are drawing.

The book is divided into three parts. The first section, *Tools and Materials*, looks at the wide range of art materials available, and suggests techniques most

suited to each. It also considers other essential items of equipment. The second section, *Techniques*, describes various methods for observing and recording your chosen subject. These two parts should be looked at in conjunction: the first one describing the materials available, the second the ways in which they can be used to articulate the language of drawing – line, tone, color, texture, and so on.

The third section, *Projects*, puts theory into practice with a series of practical projects that explore both the materials and techniques described in the first two sections, and the ways in which subjects allow for a number of different approaches and interpretations. It also suggests ways for developing your work beyond

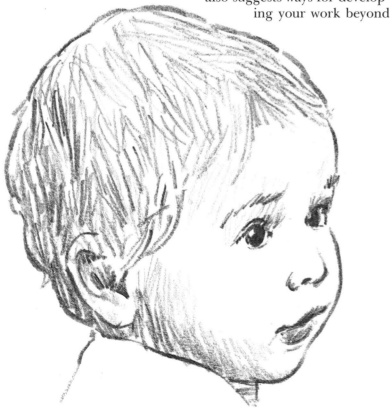

the specific projects, depending on what materials and approaches you find most satisfying.

Experimentation is an important aspect of sketching, both in terms of getting to know your materials, and in exploring the potential for different techniques and subjects. Make use of the subjects that are all around you for this – at home, outside, or on the way to work. And don't feel constrained by the need to produce tidy or "finished" drawings. Sketches are by their nature spontaneous and unfinished. Even if you produce more considered drawings, they are finished when you have said what you want to say about the subject, not when the drawing has achieved some theoretical level of clarity and detail.

A Brief History of Sketching

As the discovery of prehistoric cave paintings has proved, drawing is nearly as old as the human race, and the desire to make pictures has been evident throughout human history. The Egyptians drew on papyrus with an ink made from powdered earth, and used pens to draw on clay tablets, while the Romans designed pens with solid nibs for drawing. During the Dark Ages in Europe, manuscripts were decorated with drawn patterns and figures. And in the Middle Ages, drawing was used for architectural plans, as well as designs for statues and mosaics. However, up until the sixteenth century, drawing existed to serve other areas of artistic activity, rather than being considered as a subject in itself.

During the Renaissance, Italian artists produced large numbers of sketches and studies, particularly of the human form and of nature subjects, for their own use and as models for paintings to be followed by their studio assistants. The notebooks of Leonardo da Vinci (1492–1519), and the studies by artists such as Michelangelo (1475–1564) and Raphael (1483–1520), are prime examples. Sometimes sheets of drawings were bound together into sketchbooks and handed on from one generation to the next. At this time, charcoal and brown and white chalk were widely used, and sketches predominated over finished drawings. Although drawings were made primarily as prepara-

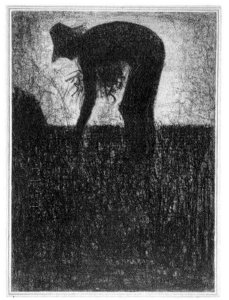

LEFT *The Gleaners* by Georges Seurat (1859–91), done in black conté chalk, derives its power from the interplay of simple dark shapes against the light.

tions for paintings, they began to acquire the status of works of art in their own right.

In Northern Europe at this time, a major champion of the art of drawing and master of a wide range of techniques was the German painter Albrecht Dürer (1471–1528). In his drawings and etchings, he achieved a range of tones with linear means that was closer to painting than drawing. Pieter Bruegal the Elder (c.1520–69), influenced by Dürer, made drawings of ordinary people and country scenes that were astonishing in their detail, while capturing the broad sweep of everyday life, and which were much admired in their own right, too.

The great Flemish painter Peter Paul Rubens (1577–1640) was one of the early masters who believed that drawing was integral to the development of the artist, and he ran a school for draftsmen and engravers. Rembrandt (1606–69) drew copiously both as preparation for paintings and to record intimate family scenes that have great spontaneity and freshness.

During the seventeenth century, landscape drawing came into its own with the work of such artists as Claude Lorrain (1600–82). He made a very large number of drawings in front of the subject, chiefly

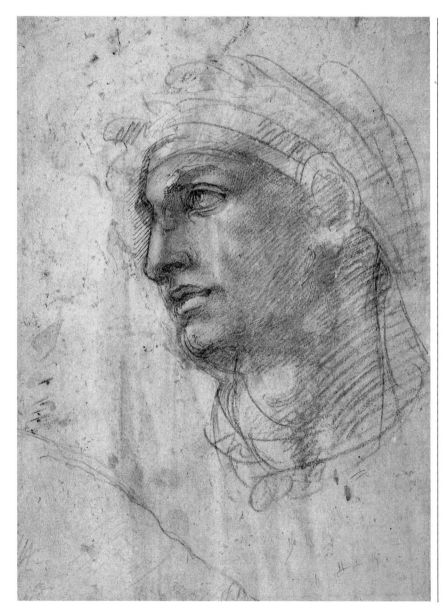

In this charcoal study of a head by
Michelangelo, the finely modeled features of
the face and the more loosely drawn areas
combine to produce an image of great
beauty and intensity.

to study the effect of light. Nicholas Poussin (1593–1665) also drew from nature, producing timeless studies of landscape features that provided material for his paintings.

The graphite pencil first appeared around the end of the eighteenth century. At this time, John Constable (1776–1837) was drawing rural scenes of great expressiveness, while J.M.W. Turner (1775–1851) used the new medium to develop his powers of observation through drawing. The pencil made possible precise drawings done with a fine line. In the work of the French artist Jean Auguste Dominique Ingres (1780–1867), whose drawings were characterized by a strict linearity, pencil drawings achieved classical status.

During the later part of the nineteenth century, the French Impressionists and Post-Impressionists began to take drawings in new directions. Line predominated in the work of artists such as Edgar Degas (1834–1917) and Paul Cézanne (1839–1906), although Degas is also famous for his wonderful pastel drawings. Vincent van Gogh (1853–90) made drawings that described the landscape, through intricate patterns of linear marks, while Georges Seurat (1859–91) produced tonal drawings using conté chalks on textured paper, which have a wonderful richness and luminosity. Pierre Bonnard (1867–1947) produced rapid, expressive sketches that were full of texture and depth, which he used as the basis for his paintings. By this time, drawings were being shown in galleries in their own right, and framed and hung in homes.

Drawing has remained fundamental to the work of twentieth-century artists, and approaches have continued to multiply. The line drawings of such artists as Pablo Picasso (1881–1973) and Henri Matisse (1869–1954) attained a new level of simplicity and expression. The role of drawing as a subordinate and preparatory stage for painting is far less important now than in the past, and the practice is enjoyed more for its own sake.

Helpful Terms

Aerial perspective
The way in which the atmosphere reduces the strength of the tones and colors that we see, as they recede into the distance. This phenomenon is used in drawings to describe receding space by making the tones progressively lighter as the subject recedes toward the horizon.

Brightness
Usually used in reference to color. It refers to a color's depth of saturation, or strength, and is measured from full strength to very muted. It shouldn't be confused with tone, which refers to a color's lightness or darkness.

Complementary color
Colors that are opposite each other on the color wheel are referred to as complementary. The complementary pairs are red and green, blue and orange, and violet and yellow. Each pair contains all three primary colors.

Composition
The process of arranging the different elements in the picture into a design, which leads or draws the eye to the main area of interest.

Contrast
The placing of two opposites next to each other: light next to dark, a small shape next to a large one, a bright color next to a dull one, a rough texture next to a smooth one. Contrast of any sort creates a focus of interest within the picture that draws the viewer's eye.

Crosshatching
Lines are drawn parallel to each other across an area of the drawing, and another set of lines are drawn over the top at an angle to the first ones. Layers can be built up in this way, until the area has become as dark or dense as you want it to be.

Form
The three-dimensional nature of objects. The form of an object is revealed by light falling across it, illuminating some surfaces while others remain in shadow.

Harmony
Similar tones, colors, shapes, textures, and so on – the opposite of contrast. Harmonious areas do not draw attention in the way that contrasts do, and balanced compositions contain both.

Hue
The color of a particular paint or chalk – red, yellow, green, and so on.

Key
The tonal mood of a picture. High-key pictures are pitched at the lighter end of the tonal scale, while low-key pictures are pitched at the darker end. In both, the range of tones is condensed to a few, although touches of the other may be included for contrast.

Linear perspective

A method of depicting three-dimensional objects on a two-dimensional surface. It is based on the fact that parallel lines running away from the viewer appear to converge toward the horizon. As a result, objects or parts of objects that are further away from the viewer look smaller than those that are close. It can also be used to draw objects in the correct scale.

Monochrome

Literally, one color. It is most commonly used to describe a black and white image, but it includes any image done in a single color, including a drawing done in different tones of the same color.

Plane

A flat surface. Objects are made up of many planes, all facing in different directions. Changes in

plane can be abrupt, such as two sides of a cube, or curved and gradual, such as a sphere. Changes of plane in an object, abrupt or gradual, are perceived through changes in tone.

Primary colors

The three primary colors are red, yellow, and blue. They are called primary because they are the only colors that can not be made by mixing together other colors in the palette.

Scumbling

A layer of thin or semi-transparent color – pastels or paint – is applied over another color so that the color underneath shows through.

Secondary colors

The colors made by mixing two primary colors: green, mixed from blue and yellow; violet, mixed from blue and red; and orange, mixed from red and yellow.

Tertiary colors

The colors that are made by mixing two adjacent primary and secondary colors.

Tone

The lightness or darkness of an object or area, regardless of its color. In relation to objects, it also refers to the amount of light being reflected by a surface.

Tooth

A paper with a rough or textured surface is described as having tooth.

Wash

An area of transparent paint, such as watercolor or thin acrylic, laid across the paper with a paintbrush. Washes can be used to prepare paper for drawing on, or applied as part of the drawing itself. Washes can be layered one over another.

Tools and Materials

The first stage is to choose some materials to work with. Be adventurous
with your choice of materials and colors, even when you are only using a
few. With color materials, although there is a basic range of colors that
will cover most situations, select some colors that you particularly like,
and look for ways to use them. If you like to go out on sketching
expeditions, keep a set of materials ready. You can keep a second
set of the basics in a bag with sketchbooks or prepared paper, in
addition to the materials you have at home. Or keep a few things
in the car, so you always have something to work with at hand.

Drawing Materials

At its simplest, all you need to make a sketch or drawing is a pencil and a piece of paper. However, one of the delights of sketching lies in the large and diverse range of materials you can choose from. In addition, several traditional media, such as charcoal, pastels, and watercolors, are now produced in a convenient pencil form that makes them much easier to use when traveling, when you want a selection of lightweight materials that will also give you as much scope as possible for trying different approaches.

Keep an open mind about what to use for different types of drawings, and experiment with different materials to see what they feel like to use and what effects they can produce. Don't buy too many of any particular type of materials at first. Particularly avoid buying big sets of colored pencils, pastels, or paints. Get pencils in a few colors, or select a few individual tubes or pans of paint, and try them out before committing yourself to a wider range.

Keep your sketching materials light, so they will easily fit into a bag and not be a bur-den when you are out on expeditions looking for subjects.

For working on loose sheets of paper, rather than sketchbooks and pads, you will need a drawing board. A sketching easel – available in either wood or metal – is an asset, but it is possible to improvise some kind of suitable support.

Many types of color materials are available, including pastel pencils and color pencils.

Carpenters' pencils are a useful addition to your sketching kit. The point can be varied to suit the work you are doing.

A sponge is useful for watercolor painting and for preparing paper with washes prior to drawing.

Thick and thin charcoal sticks – have some of each in your collection.

Soft pastels are available in round and square form.

Masking tape is used for securing paper to the drawing board.

The range of pencils available for sketching work includes graphite and charcoal pencils – have both in order to give yourself plenty of options.

Papers are available in a wide range of colors and textures, and these are particularly useful for working with pastels.

A kneaded eraser can be used with all drawing media for blending, removing unwanted marks, and for drawing back into the image to create lighter tones and to lift out highlights.

Drawing and mapping pens can be used for sketching. They make more variable and incisive lines than felt-tip pens.

A graphite stick provides a good alternative to pencils.

Watercolor pans

Pencils

Graphite pencils are available in several grades of softness. Begin with more tentative lines and marks, and gradually strengthen them as the image takes shape.

The simple pencil is a supremely versatile drawing instrument. It can be used to create lines and marks of greatly varying character; it can be used for tonal drawings; it can be easily erased and reworked; and it can be combined with other media, such as pen and ink or watercolor washes.

Pencils come in round and six-sided versions, the latter being the most common. The round ones can be rolled between the fingers as you draw, producing a free and varied line with great character. The tendency of round pencils to slip in the fingers can be a disad-

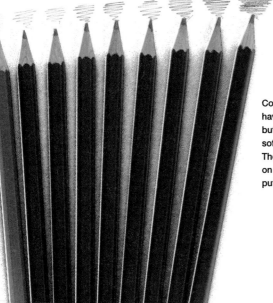

Conté pencils have a rough feel, but produce a soft, flowing line. They can be used on their sides to put in shading.

Graphite sticks are available in a range of grades. They make a smooth, responsive line, and can be used on any kind of paper.

14

vantage, however, if you are trying to produce evenly shaded areas of tone.

Graphite pencils come in several grades, from very hard to very soft: H to 6H designating hard to very hard, HB to 9B soft to very soft. Charcoal pencils are available in a small range of grays, from light to dark. They smudge quite easily. Conté pencils, which are available in earth reds and browns, black and white, have a more waxy, and sometimes a rougher, feel than graphite and charcoal. Some types are not easy to smudge effectively, but they produce a soft, flowing line.

Graphite pencils can be used with any type of paper surface, depending whether you want a smooth, even, continuous line, or a broken, rough or darker-toned effect (see page 42). Charcoal pencils are best used on medium and rough paper surfaces.

To start sketching, you will need HB, 2B, 4B, and 6B graphite pencils, a charcoal pencil, and some conté pencils.

Sharpening pencils

The best way to sharpen pencils is with a sharp blade or craft knife, which will enable you to bring the pencil to a very sharp point while wasting as little of the lead as possible.

If you do use a pencil sharpener, replace the blade as soon as it starts to become blunt.

Water-soluble pencils can be used as plain pencils or converted into a wash.

Sketching pencils in a range of earth colors. These have a smooth feel, but do not smudge easily.

The uneven action of a blunt blade can easily break the point of your pencil as you sharpen it, using up the lead unnecessarily.

Carpenters' pencils are available in graphite form, and in white and a range of earth colors. They can be used to make broad, blocky marks, or to put in blocks of tone quickly.

Charcoal and Chalks

Charcoal is soft and responsive, and smudges easily. It can be used on end for lines and scribbles, or on its side to put in blocks of tone quickly, and it can be blended or drawn into using a kneaded eraser.

Charcoal is an extremely expressive drawing tool. The slightest touch of a piece to paper will produce a subtle mark, and the range of tones you can achieve with it is endless. There are two types of charcoal: willow and compressed. Willow charcoal sticks come in various thicknesses from thin to thick (called scene-painters' charcoal). The thinner sticks, in particular, break easily if used vigorously. You can use charcoal on its end to create lines, or on its side to block in large areas of tone, and you can smudge it easily for a soft effect. The speed with which you can use it, whether for line or tone, makes it particularly well-suited for large-scale work. Compressed charcoal is much more waxy than willow, and produces darker marks that are more difficult to manipulate on the paper.

When choosing paper for charcoal work, go for medium or rough surfaces, rather than smooth, because the pits in the paper pick up and hold more charcoal, making it much easier to produce rich, dark tones. A textured paper also breaks up denser areas of tone.

16

Conté chalks come in the form of square or round sticks. They are more chalky than conté pencils, but are not as soft as willow charcoal. They are available in black, white, and a range of warm and cool grays, and in a variety of red and brown earth colors, such as terra-cotta, Venetian red, sanguine, and sepia. These chalks work particularly well on colored papers, especially mid-toned grays and warm earth colors, with the paper being allowed to show through as one of the tones or colors in the drawing (Project 7).

It is all too easy to make a mess with charcoal, to get it on your hands, then smudge it on your paper, for example. Handle it carefully, and once you have completed a drawing, always fix it straight away to prevent the charcoal from accidentally smudging or moving (page 27).

Chalks in black and white, and a range of warm and cool grays, make a good alternative to charcoal for tonal drawings, but are less easy to use.

Compressed charcoal produces dark, dense marks and is difficult to smudge effectively.

Conté chalks in grays and earth colors

Pen and Ink

Indian drawing ink

China palette with compartments for diluting ink to different strengths.

Drawing with pen and ink can be a daunting prospect because you appear to have only one chance to get it right. However, in reality, drawings consist of many lines and marks, and what may in the beginning appear to be lines made in the wrong place, can turn out to provide a good basis for areas of shadow, or they may just not be very obvious in the final, fully worked-up drawing.

An ever-increasing range of pens is available, including traditional dip and mapping pens with steel nibs, refillable fountain pens with drawing nibs (an italic nib can also be used for drawing), various rollerball and felt-tip types, and technical drawing pens. The latter are very convenient, and come in various widths, but they do not give the potential for flexibility of marks that steel drawing nibs do. Steel nibs broaden under pressure, making it easy to produce variations in a line. To begin with, a pen with interchangeable nibs is your best option,

A nib holder with a range of nibs. The nib reservoir should be filled using a fine brush.

in addition to one or two rollerball or technical pens for convenience when you are doing quick sketches outdoors.

Inks come in black and a range of colors. There are two types: waterproof and water-soluble. If you are using a pen line in conjunction with washes, make sure you use a waterproof ink, or the water from the paint will blur the ink. You can vary the tonal quality of an ink line by diluting the ink to varying degrees, which gives dip and fountain pens another expressive advantage over other types. The character of the line can also be varied by working on dampened, rather than dry, paper.

When working in pen and ink, choose smooth watercolor paper, which has a ready-sized surface. If you use ink on an unsized surface, it may be absorbed by the paper, producing a fuzzy line.

Rapidograph pens come with cartridges, and are available in different point widths. They make a fine, even, flowing line.

A Chinese brush is good for calligraphic marks. Hold it vertically and move your whole arm.

Even ballpoint pens are useful for sketching.

Color Materials

Felt-tip pens provide a direct, immediate sketching medium.

There are various types of colored pencils on the market, all offering different qualities and possibilities. You can use them individually, or in combination.

You will find that color pencils vary greatly in softness, depending on the manufacturer. Some produce soft colors, even in the stronger, darker tones, while others produce far more intense colors. All good-quality pencils sought to be firm in texture, and you should be able to bring them to a sharp point. You can use color pencils to draw with line, or to shade in areas of color with closely hatched lines. Of course, you can't mix color in the way you do paints, but you will discover a variety of optical and broken-color mixing techniques that produce either subtle or vibrant effects (see pages 54–7).

Water-soluble pencils will enable you to combine drawing and painting within the one medium. You can use them in a number of ways. The most common and useful method is to draw with them onto your paper, before dissolving the color with a brush loaded with water to produce flat washes or to blend two or more colors. Lines worked over damp paper will spread slightly and have a soft, furred quality.

Pastel and charcoal pencils produce strong, pure, vibrant colors, and soft pastel pencils provide a very convenient and lightweight color medium. You can smudge or blend them with a finger, but they can not be used to block in large, flat areas of color quickly, in the way that pastel sticks can. As with charcoal, you must fix drawings done with these pencils. Color pencils can be used on smooth or rough papers.

Felt-tip pens come in thin and broad-tipped varieties, and a large range of colours. Look for water-based rather than spirit-based pens, as the latter may "bleed" into the paper and go right through, which would be annoying if you are using a sketchbook.

Pastel pencils can produce areas of dense, vibrant color, and provide strong color in a convenient form.

Color pencils can be used with heavy pressure for strong colors, or for soft shading.

Watercolor pencils can be used as plain color pencils, or water can be applied to dissolve the color in order to blend colors or produce a wash.

Pastels and Chalks

Square pastels

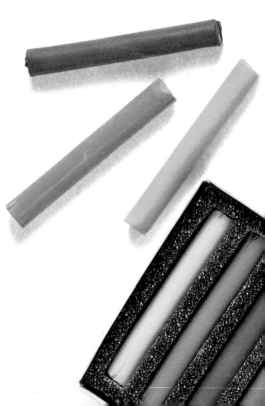

Pastels and chalks allow for a spontaneous and expressive approach to sketching, and provide a way of using color in a very pure and direct form.

Soft pastels have a wonderful chalky, smudgy quality, and are available in a wide range of colors and tints. They come in round and square form, and can be bought in boxed sets, or singly. Pastel sticks are more versatile than pastel pencils, but not so convenient when you are traveling or sketching on location. Soft pastels vary in softness from one make to another, so you may want to try one or two different brands to see which you prefer the feel of.

Drawing chalks are harder in texture than pastels, and less easy to move about and smudge when they are applied to the paper.

Oil pastels have a soft, slightly greasy quality. They come in a smaller range of colors than soft pastels, and are very difficult to manipulate on the paper. However, they are soluble in turpentine, and can be applied and then rubbed and blended with a cloth or cotton swab dipped in turpentine to produce a smooth, transparent layer of color. Another way to use them is to apply layers of color on the paper, and then scrape off or draw into the top layers to reveal the color underneath.

22

Oil sticks are an alternative to oil pastels.

Pastels can be used with any paper that has a slight tooth. Textured pastel papers are available in a large range of colors, and medium and rough watercolor papers can also be used. Artists'-quality sandpaper, for use with soft pastels, is available from art suppliers, and is an excellent surface if you want to build up several layers of color.

Soft pastels and chalks are easily rubbed or smudged accidentally, so to avoid mistakes, fix them when you have finished (see page 27). Drawings should also be stored carefully. Tape a sheet of tracing paper in place over them to stop anything rubbing against the surface.

Soft pastels can be blended easily, but do not overblend them or the work will look overblended and dull. Soft pastels crumble easily, so handle them with care.

Oil pastels come in intense, vibrant colors. They are difficult to smudge without using turpentine.

Water-soluble crayons are waxy, like oil pastels, but can be smudged using water.

Paints and Brushes

Acrylic paints can be used for thin washes, or thick and opaque.

Paints provide exciting and flexible media for sketching, whether you use them on their own or combined with other media. This might sound like a contradiction in terms, because you probably think of drawing as a dry medium technique. You can use wet media for sketching, however, and they will broaden your scope considerably. Watercolor, gouache, and acrylics are convenient to use and light to carry, and it isn't necessary to work with a large range of colors. Watercolors are available in small sketching sets. If you want to buy individual tubes or pans of paint, the basic palette listed on page 56 will give you a good basis to build on. Brushes for drawing include both watercolor, either sable, sable/synthetic mixtures, or synthetic. Sable brushes are expensive, but they have a wonderful springiness in the bristles and last a long time. Chinese brushes also make excellent drawing tools.

Gouche paints are opaque, and can be applied in thick or thin layers.

Brushes can be used with paints or drawing inks, and are very expressive; their softness allowing them to respond to the slightest changes in pressure and direction. They can be used either loaded with paint, or quite dry for a dragged effect.

Water-based paints should be used on stretched paper (see page 72), because unstretched paper buckles when it is wet, or on the type of watercolor blocks that contain sheets of paper glued down on all four sides, although even these will buckle a little. If you want to work in a watercolor sketchbook, choose one with the heaviest type of paper.

Full and half-size water-color pans. Watercolors are also available in tubes. Watercolor paint is transparent when applied to paper.

Use fine brushes for details, and larger brushes for putting in larger areas. Try to use the largest brush that the area being painted will allow.

Pocket-sized watercolor sketching set

Papers and Accessories

The overall impression that a drawing makes results from the interaction between the medium used and the paper texture, so the choice of paper for a drawing is an important creative decision. Some papers are more suitable for use with particular media than others, so make sure you choose the most suitable option.

There are three main categories of paper surface for drawing and watercolor papers: HP (hot pressed) or smooth, CP (cold-pressed) or medium rough, and rough. Papers also vary in weight, which is expressed in pounds per ream (lb). A lightweight sketch or watercolor paper is about 70 lb, and a heavy watercolor paper is 140 lb, although the most substantial watercolor is 300 lb. Papers that are going to be used with paint or wash techniques should be stretched first (see page 72).

A range of papers in different colors and surfaces, and sketch pads

A torchon for blending charcoal and pastels

Fixative is available in aerosol form, or can be applied with a diffuser spray.

Drawings can be rolled up and carried in an extendable tube.

Other essentials are a drawing board, masking tape or clips, fixative and erasers, a craft knife for sharpening pencils, and palettes for mixing washes and colors. Buy these as you go along to avoid a huge initial outlay in cost.

Fixing a drawing

Drawings done with graphite or charcoal pencils, pastels, charcoal, or chalks need fixing to prevent them from being accidentally damaged during framing or storage. Fixative is available in aerosols, or in bottles for use with a diffuser spray. The diffuser has two sections set at a right angle, and is used by dipping the end of one section in the fixative and blowing through the mouthpiece on the other section.

It is important not to soak the drawing with fixative, because this will dull the medium used. To avoid this, don't point the fixative directly at the drawing. Instead, lay the paper flat and spray onto it horizontally, letting the fixative fall onto the drawing in a fine shower. Move the can from side to side across the full width of the paper, working from top to bottom, to give the drawing a light, but even, coverage. It is better to apply two light coats, letting the first dry, rather than one heavy coat, which is more likely to affect the quality of the artwork. Try spraying onto newspaper first to practice.

Large clips can be used to hold your paper in place, instead of masking tape.

Techniques

Once you have chosen some art materials to use, you will be ready to start experimenting with them. This section explains how to produce drawings with lines of greatly differing character, to model forms, create a sense of space, describe mood and atmosphere through color, convey a sense of texture and movement, and experiment with combinations of media. Always remember that techniques are a means to an end, not an end in themselves. Once you have decided on the subject for a drawing, ascertain what qualities you particularly want to convey or stress, and then select the materials and techniques that will best allow you to do just that.

Getting Started

It is important to experiment with materials to discover just what you can do with them. Have some paper and drawing materials nearby as you read through this section, and try out the ways of handling materials being described. Don't worry about making mistakes – the more you practice, the better your results will be.

Before starting a drawing, especially if you haven't done any for a little while, do some warm-up doodles on a large sheet of paper. Use your arm from the shoulder and work quickly across the paper, varying the pressure and direction of the marks you are making in order to loosen up your arm.

There are various ways of holding any drawing instrument, whether you use a pencil, pen, or piece of chalk: it can be held like a pen, near the point or nib, or toward the other end, which will feel less controlled but can produce an interesting, freer line; or it can be held in the palm with all the fingers wrapped around it, with the palm facing either up or down. The nearer to the drawing end that you hold your tool, the more control you will have over the marks you make, and the easier it will be to produce effects like evenly-shaded areas.

When starting out, it's important to hold your pencil or chalk in a way that feels comfortable and natural, while allowing you to work freely and quickly across the paper. After a while, you may want to try different handling methods, according to the effects you want to create – using the pencil or chalk on its point or its side, exerting heavy pressure or a light touch, and making regular, controlled strokes, or fast gestural marks.

The position of your drawing board or sketch pad is an important factor, too. Have it in as upright a position as possible. If you don't have an easel and are working sitting down, stand a drawing board on your knees and lean it against an object, such as a chair back. Alternatively, hold it at the top to keep it upright. If you work with the paper flat on your knees or on a table, the angle of the perspective will slightly distort the image, making it almost impossible to record your observations accurately, and you will constantly be moving your head up and down to look from subject to paper. This makes consistent observation of your subject more difficult than if you just move your head slightly from left to right.

Observation

Observation exists at the very heart of drawing, which is, after all, a process of looking at the world around you and recording what you see. Careful measuring and knowledge of linear perspective can help to produce accurate drawings, but the same information can be observed through thoughtful observation, and it is best not to rely on a systematic approach.

To analyze the proportions of a subject, select an element within the subject area that will remain still and constant, and use this as your measuring unit, comparing all the parts of the subject to that. If you are drawing a figure, for example, see how many times that unit goes into the height and width of the body in order to establish the overall proportions. Then assess the length or width of individual parts of the subject against the measuring unit. This method can be used to produce a measured drawing of the entire subject, or to sort out specific elements that are giving you problems.

Subjects are often surrounded by structures that provide a natural grid. Door and window frames, corners of a room, the sides of large pieces of furniture, shelves, and mantelpieces all provide vertical and horizontal lines against which you can judge the angles and proportions of the subject.

Horizontals and verticals can also help to establish the angle or direction of an element in a composition. If you are not sure how to place something, hold up a pencil in a horizontal or vertical position, then swing it around until it aligns with the object in question and note in your mind's eye the angle between the object and the vertical or horizontal. It is surprising how wrong one's initial assessment of this can be – you sometimes discover that a line or edge you thought slanted slightly downward actually slants upward, or that an edge that looks at an angle is actually on the horizontal. This type of discovery can bring the whole of the rest of the drawing right.

To start with, you will probably find that when you test your accuracy by measuring angles and proportions, your observations will be quite inaccurate, but with practice your drawings will become more precise.

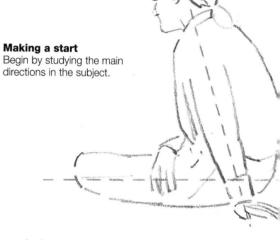

Making a start
Begin by studying the main directions in the subject.

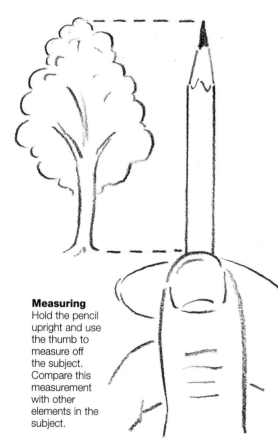

Measuring
Hold the pencil upright and use the thumb to measure off the subject. Compare this measurement with other elements in the subject.

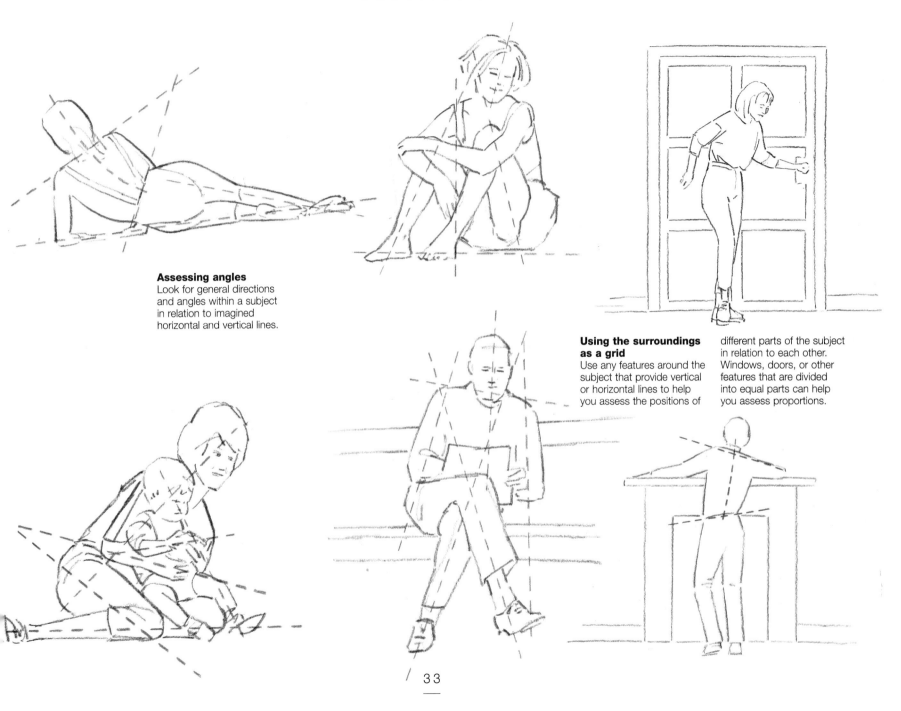

Assessing angles
Look for general directions and angles within a subject in relation to imagined horizontal and vertical lines.

Using the surroundings as a grid
Use any features around the subject that provide vertical or horizontal lines to help you assess the positions of different parts of the subject in relation to each other. Windows, doors, or other features that are divided into equal parts can help you assess proportions.

Scale and Shape

The distance between you and different elements within your overall subject area affects how you see each of the features. The further away an object is, the smaller it will look in relation to things that are close to you, regardless of their relative sizes if they are placed next to each other.

As a simple experiment, hold your hands out in front of you, with one close to your face and the other as far away as possible. Now overlap them slightly. Notice where the tips of the fingers and the base of your further hand intercept the nearer hand, and how much smaller the further hand now appears. This is easier if you close one eye. As you walk down the street, study the relative sizes of people near you against those a long way off. This way of looking can be applied to any subject; try to develop it by looking at the world around you in an analytical way as

much as possible. A more formal approach to getting different elements in a scene in the right scale is through the use of linear perspective (page 36).

When including objects that exist on different planes in your drawings, the size of each must be logical in relation to their position in space. The fact that the closer something is to you, the larger it appears – known as foreshortening – affects everything you draw. If someone extends an arm toward you, the hand will appear a similar size to their head, and you will see very little of the arm – study this effect in a mirror.

A different way to look at the subject is to see it as a series of flat, interlocking shapes. In drawing any subject, you should observe the shapes between and around subjects – known as negative shapes – as well as the subjects themselves – the positive shapes.

As far as composition goes, negative shapes are as important as positive shapes. Strong compositions have interesting negative as well as positive shapes – but they can also provide useful clues for drawing the subject. For example, if someone is standing with their hand on their hip, by drawing the triangular shape formed by the crooked arm and the body you can establish the correct position of the arm.

Positive and negative shapes
A subject is made up of a series of shapes formed by the objects in the composition and by the spaces around them. Negative shapes are just as important as positive ones in creating a strong composition, and can be used to balance the main shapes.

FROM THE LEFT 1 The composition is made up of simple interlocking shapes. **2** The shape in the background defines the shape of the jug, and balances the bottle. **3** The shapes formed by the foreground and window balance each other. **4** The background shape defines the bottle and balances the jug.

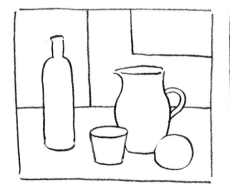
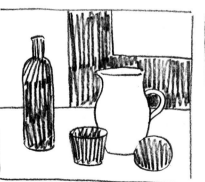
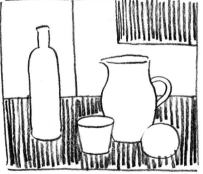
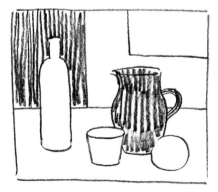

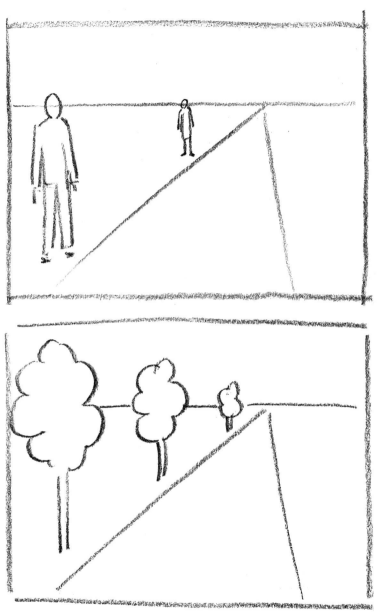

LEFT AND BELOW LEFT
Figures and objects that are closer to you will appear larger than those further away. The extent to which things reduce in size is in direct relation to their distance from the viewer. This relationship can be observed by eye by assessing the size of a feature in the foreground against those further away.

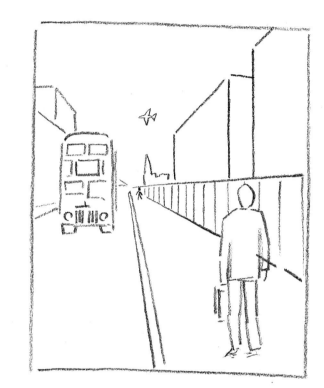

ABOVE AND LEFT The relative sizes of objects should be logical according to their positions in space, even if it makes no sense in reality. The relative sizes of people and objects conveys how far away they are.

P e r s p e c t i v e

Linear perspective is a system of reproducing three-dimensional objects on a flat surface so they recede in space and sit squarely on the ground. This drawing system is based on the fact that all parallel lines running away from the viewer appear to converge at the horizon. The same effect occurs with parallel lines extending away from you vertically, such as the sides of a high-rise building when you look up at it.

The point at which parallel lines converge is known as the vanishing point, and represents infinity. It is this that provides the clue to getting objects at different distances away from you in the correct scale. Perspective affects two- and three-dimensional shapes and forms. A rectangle that is square to the picture plane has horizontal sides parallel and vertical sides parallel. As soon as the rectangle is tilted, the horizontal sides remain parallel, but the vertical sides, which extend away from the viewer, start to converge toward each other. The more the rectangle is tilted, the more sharply the sides converge. If extended, the point where the two sides meet would be on the horizon line.

With three-dimensional forms that are angled so you can see two sides, the perspective lines of each side will extend to different vanishing points on the horizon line.

Circular and cylindrical shapes are also affected by perspective. A circle seen square on is round, but the more oblique the angle from which you look at the subject, the more elongated the circle appears.

Rectangles
BELOW A rectangle is square-sided seen straight on. The greater the angle at which it is seen, the more sharply the sides converge toward each other and the narrower it becomes from front to back.

RIGHT Exactly the same effect occurs with an upright square or rectangle. This effect can be studied in an open door or window.

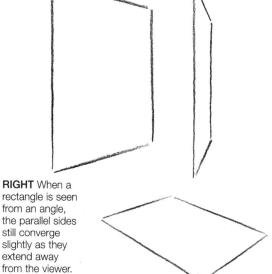

RIGHT When a rectangle is seen from an angle, the parallel sides still converge slightly as they extend away from the viewer.

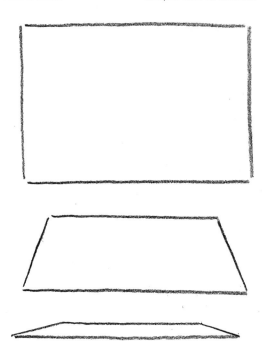

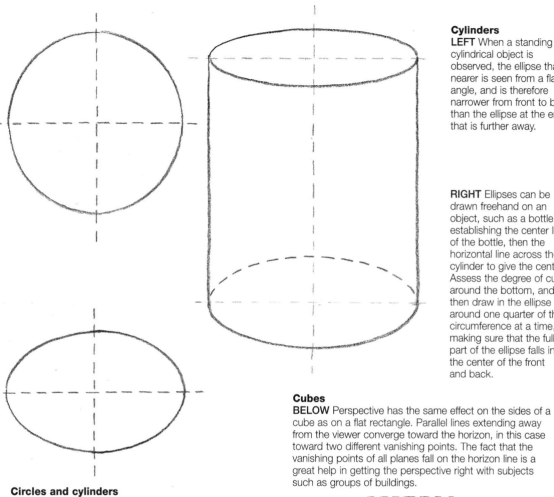

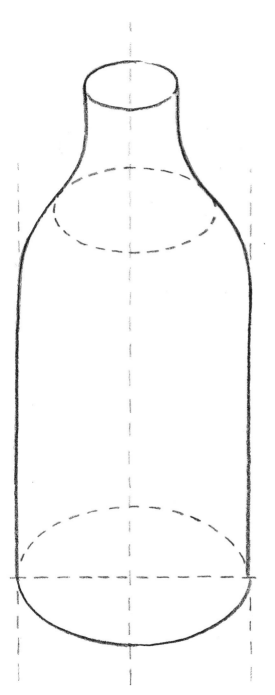

Cylinders

LEFT When a standing cylindrical object is observed, the ellipse that is nearer is seen from a flatter angle, and is therefore narrower from front to back than the ellipse at the end that is further away.

RIGHT Ellipses can be drawn freehand on an object, such as a bottle, by establishing the center line of the bottle, then the horizontal line across the cylinder to give the center. Assess the degree of curve around the bottom, and then draw in the ellipse around one quarter of the circumference at a time, making sure that the fullest part of the ellipse falls in the center of the front and back.

Cubes

BELOW Perspective has the same effect on the sides of a cube as on a flat rectangle. Parallel lines extending away from the viewer converge toward the horizon, in this case toward two different vanishing points. The fact that the vanishing points of all planes fall on the horizon line is a great help in getting the perspective right with subjects such as groups of buildings.

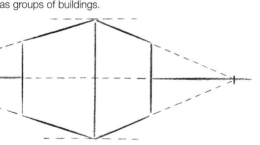

Circles and cylinders

Perspective affects circles and ellipses in the same way as rectangles. The flatter the angle from which a circle is seen, the more elliptical it becomes.

Composition

Composition refers to the way in which you arrange elements in the subject on paper. The most important decisions you have to make about composition when sketching are: the angle of view, how much of the subject to include, and the overall shape of the subject.

You should look at the subject from different angles before selecting the final composition, whether you are drawing from a still life set-up at home or outdoors in the landscape. You can either work on the level with the subject, get above it and look down, or get down low and look up. A quite mundane subject can suddenly become very exciting through a change of viewpoint.

The horizon exists on a level with your eye, so a high viewpoint gives rise to a high horizon, and a low viewpoint to a low horizon. If you can not see the horizon, you can establish where it would be by establishing your eye level: hold up a pencil in a horizontal position in front of your eyes and note where it intersects the subject. This is your eye level. One of the first decisions you need to make is where you are going to position the eye level on the paper – or what alternative viewpoint you are going to take.

There are often several options when it comes to framing and composing a picture, and it can be difficult to decide how much to include, as well as whether the composition should be vertical or horizontal. To help, you can do little thumbnail sketches of your intended composition before starting. And you can either use a viewfinder – a rectangle cut out of the center of a piece of cardboard – or your hands to frame the subject while you assess it.

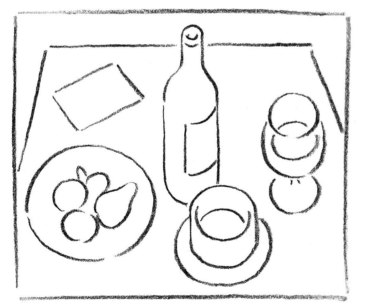

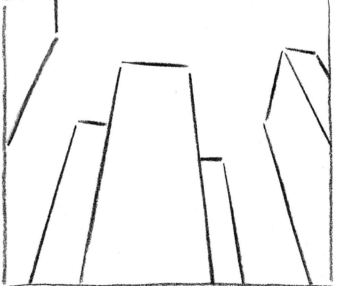

Viewpoint

FAR LEFT A high viewpoint, looking down on the subject, can provide an unusual composition in which shapes are emphasized and space is flattened.

LEFT A low viewpoint, looking up at the subject, emphasizes perspective effects and makes the subject seem to tower over the viewer.

Subjects can be framed in several different ways, and there is not always an obvious horizontal or vertical emphasis. Choose a particularly interesting area to concentrate on.

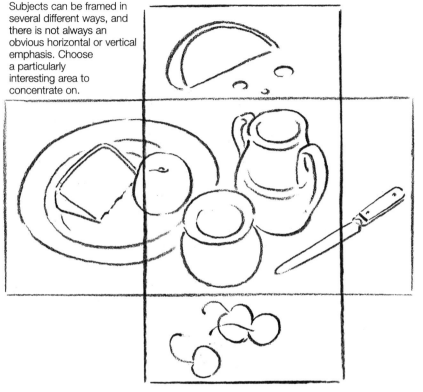

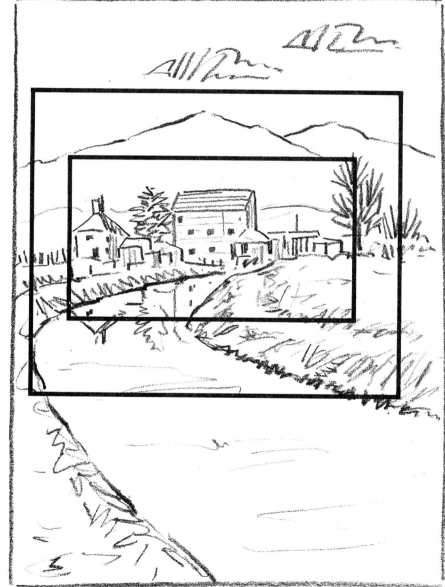

RIGHT You have various options here. The whole scene can be included, or you can make a close-up study of the buildings. However the picture is framed, make sure that the focus of interest is placed off-center.

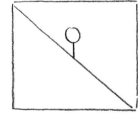

Leading diagonal
Most people read a picture from left to right, and therefore read the left-hand example as an object moving downhill, and the right-hand one as an object that is going uphill. In a drawing of a toboganner, for example, the hillside should slope from top left to bottom right; to convey that a subject is moving uphill, the slope should run from bottom left to top right. If these diagonals are reversed, the image will appear disturbing.

Line

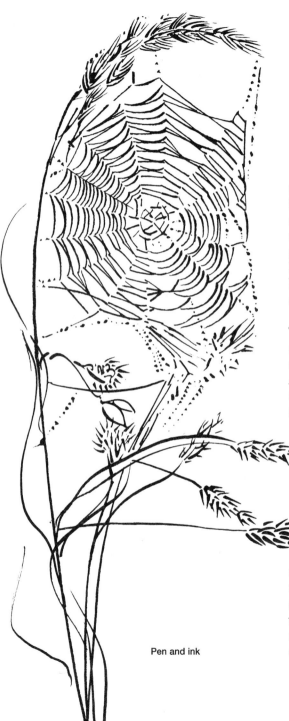

Pen and ink

Line is the most direct means of drawing, and has far more potential for varied and expressive use than you might at first imagine. Practice drawing regularly, so producing a line becomes a natural, unconscious activity, freeing you to concentrate your energies on observing your subject. When you have achieved this confidence, you will become aware of a great sense of liberty when drawing with line.

Lines can have many different qualities. They can be thick or thin, heavy or light, bold or tentative, continuous or broken. A series of dots or dashes create an implied line. Alternatively, a line can be used singly, or several fine lines can be used together, creating a vibrating outline that has a sense of movement. Don't consciously try to create a certain type of line, however. Instead, concentrate on observing the subject and recording your observations, and the expressive use of line will gradually develop as you gain in experience.

It is important not to think of drawing with line in terms of drawing outlines around everything. Lines can delineate volumes, define edges, imply direction and movement, or create texture. The speed at which a line is drawn also affects the way the onlooker will perceive it. Linear marks made fast and freely will encourage the eye to move across the paper faster, and will therefore generate energy, whereas slowly drawn, more considered lines will be quieter and more static. To suggest that objects are receding into the distance, lines and marks should get thinner and smaller in those areas that are further away. Lines in the foreground should remain strong and bold.

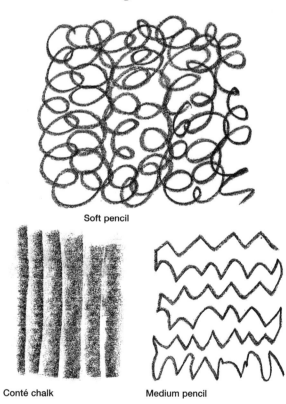

Soft pencil

Conté chalk

Medium pencil

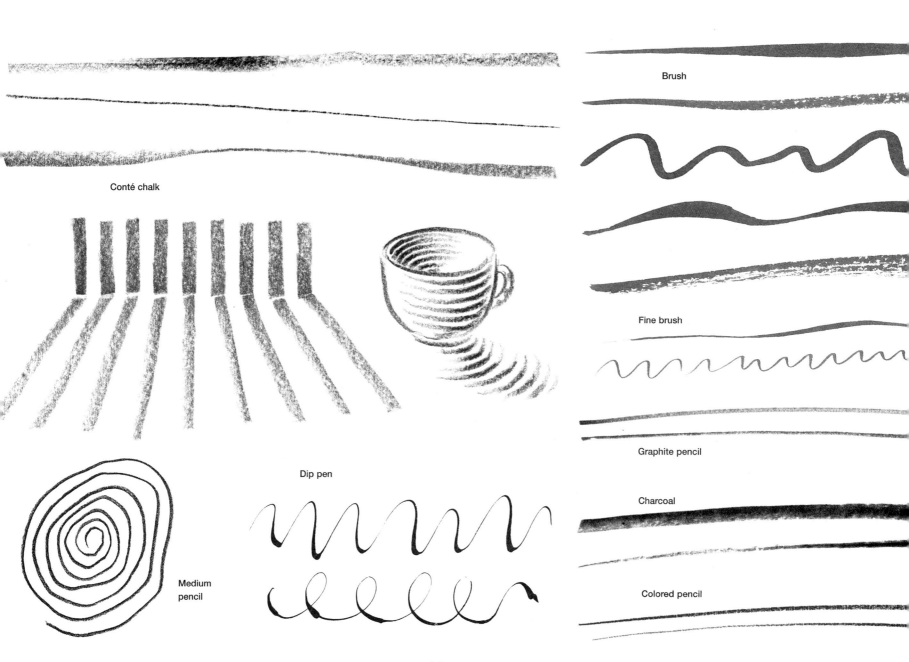

Brush

Conté chalk

Fine brush

Graphite pencil

Charcoal

Dip pen

Colored pencil

Medium
pencil

Varying the Line

Drawing materials vary enormously in their sensitivity to changes in pressure and direction. The quality of any type of line is also strongly influenced by the texture of the paper, and the way in which it interacts with the drawing instrument you are using.

If you are using a soft medium, such as soft pencils, charcoal, or brushes, which "give" under pressure, you can get great variation into a line by varying the pressure as you draw. Technical drawing pens or hard pencils cannot be varied to the same degree. Light pressure will produce a light-toned line, while heavy pressure will produce a darker-toned line. Heavy pressure used with a soft medium or implement will also create a thicker line, because the medium broadens under pressure. By increasing the pressure when producing broader, darker lines, you can suggest shadow areas

or heaviness. Lines that vary quite strongly in tone and thickness can describe tonal changes and a sense of the three-dimensional in the subject. Finer, more resistant materials are better suited to more detailed work: soft, giving materials are best suited to a broader approach.

The paper surface has a direct effect on lines drawn with different media. The rougher the texture, the more it will break up the line; and the softer the material used, the more it will be broken up by the paper surface. Try out a 2B pencil and a 6B pencil on smooth and rough papers, applying even pressure. Lines drawn on smooth paper will be crisp, continuous, and even in tone along their length. Lines drawn on rough paper will be darker in tone, rougher, and broken. Then try the same exercise with a piece of charcoal or a pastel, and a brush loaded with a wash, and the effect will be more exaggerated.

Brush and ink on smooth paper

Chisel-end 4B pencil

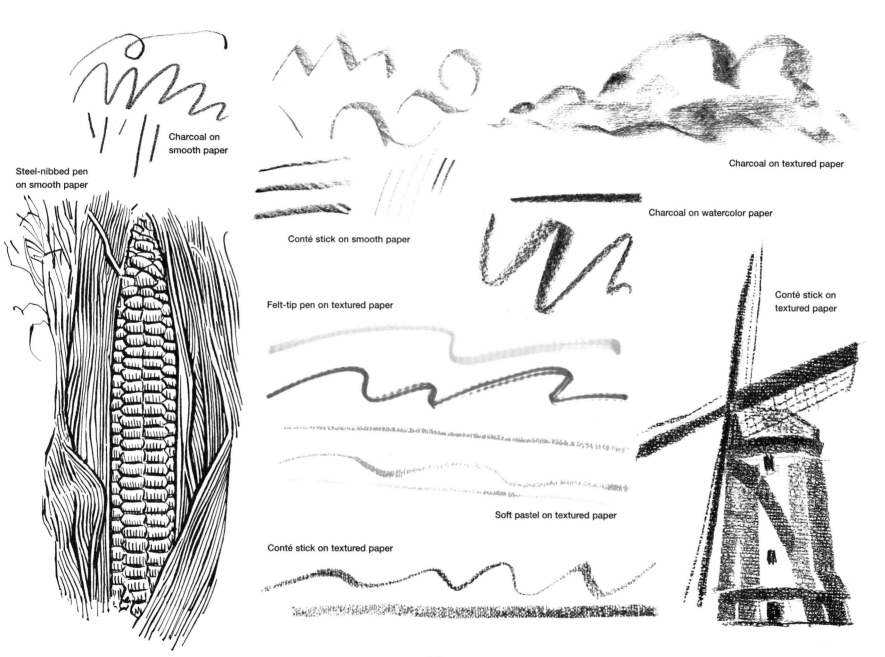

Charcoal on
smooth paper

Steel-nibbed pen
on smooth paper

Charcoal on textured paper

Charcoal on watercolor paper

Conté stick on smooth paper

Felt-tip pen on textured paper

Conté stick on
textured paper

Soft pastel on textured paper

Conté stick on textured paper

Tone

As with line, the quality of tone you produce with pencil or charcoal will partly depend on the texture of the paper. With a smooth paper, you can produce dense, solid, flat areas of tone. In contrast, when you are working on rough paper, the areas of tone will be darker but broken, with specks of paper showing through, unless you smudge the area to work the medium into the pits in its surface.

Pencils can be used on their point, drawing lines in one direction that are so close that they merge together, or on the side of the lead. To get an even, streakless area of shading, hold the pencil firmly near the point and exert consistent pressure. The larger, soft, sketching and charcoal pencils will build up tone more quickly than their graphite counterparts.

Charcoal can be used to produce large areas of tone quickly, preferably on medium or rough paper. Work the charcoal stick in different directions to create smooth, solid areas, or drag it on its side across the paper for a broken effect that allows specks of white paper to shine through. Increase the weight of tone by exerting more pressure as you draw. If you want to build up more layers of charcoal, but the paper won't take any more, fix the drawing and then continue to work over the top.

Charcoal can be rubbed or smudged with the finger or a paper stump or torchon, to manipulate it into place, or to produce a flat, solid area of tone. Beware of over-rubbing, blending, or smudging work, however, because it will make your picture look too flat and smooth, and you will lose the qualities of the surface textures.

When you are using ink or a wash, you can vary the tone by diluting the wash to different degrees. Alternatively, you can use a wash with a consistent tone, but contrast this with the dry-brush technique, which creates a dragged, broken effect, for half-tones.

Don't try to include lots of different tones at the start of a drawing because this can be confusing. Instead, mass together similar-toned areas into bigger shapes, using about five or seven tones in all. You can then add subtle variations within each shape to differentiate between individual elements.

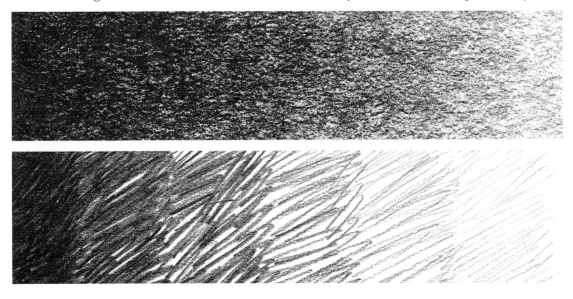

A tonal scale
The effect of these two dark-to-light scales is quite different: the smooth gradation (top) looks like a continuous surface, while the scale that jumps from one tone to the next (left) seems to move forward in space from light to dark.

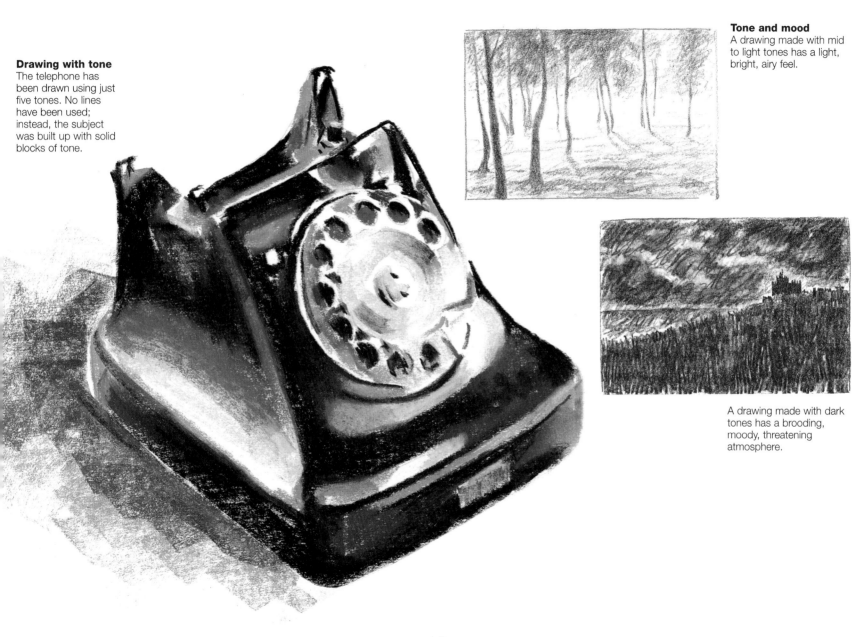

Tone and mood
A drawing made with mid to light tones has a light, bright, airy feel.

Drawing with tone
The telephone has been drawn using just five tones. No lines have been used; instead, the subject was built up with solid blocks of tone.

A drawing made with dark tones has a brooding, moody, threatening atmosphere.

45

Describing Form

To produce the impression of form and volume in your drawings, you need to capture the way in which light falls on the subject. The best way to capture the effect of light hitting an object is to describe the absence of light – i.e. shadows – in those parts of the subject where they occur. By using a full range of tones, from light to dark, you can build up an impression of the solidity and three-dimensional nature of objects.

When making a tonal drawing, forget about the outlines of individual items in the subject and analyze your subject as blocks of tone. Ignore the local color of the subject, too; that is, don't analyze your picture in terms of light or dark color. Make a mental note of the direction of the light, and observe which surfaces are lit – those facing the light source – and which are in shadow – those facing away from it. Also look for places where

light is reflected back into the shadow areas, modifying the tone there.

Tonal values are relative – each tone appears lighter or darker compared to the tones around it – so you need to judge the tone of one part of the subject against others, both near by and further away. In your drawing, first establish the lightest light and the darkest dark, and then work in the tones between them. Any adjustment to the tone in one area of your drawing will affect the way the tones around it appear, so make a mental note to continue reassessing the tonal balance as you work.

Strong contrasts between light and dark will draw the eye in to your picture, and will also seem to advance in a drawing, whereas less contrasting tones appear to recede. This is a useful way to create the illusion of space. This effect – known as aerial perspective –

can be seen on misty days, when shapes are simplified and tones are reduced, and forms seem to fade into the distance.

This does not mean that the strongest contrasts always need to appear in the foreground. Strong contrasts in the middle ground will draw the eye through the picture, providing another method of creating an impression of depth and space. Sometimes in nature, with certain weather conditions, the strongest lights and darks appear in the distance. Strong tonal contrasts between light and dark should, however, be kept away from the edge of the drawing or they can unbalance the composition by drawing the eye away from the center of interest. A strong tonal contrast can, however, be placed reasonably near the edge if it occupies a small area and is balanced by a strong element on the other side of the picture.

Modelling a cube
The three visible sides of the cube are defined by clearly distinguished light, mid and dark tones of the same color. The tone has been built up gradually by putting a light wash over all three sides, a mid tone over two sides, and a dark tone over one side. This technique insures that the cube remains unified.

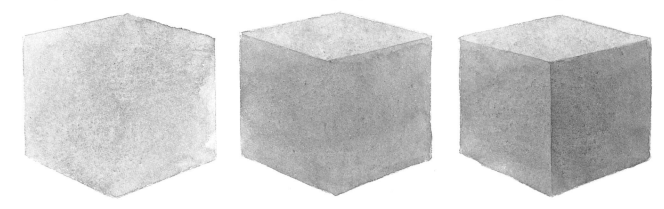

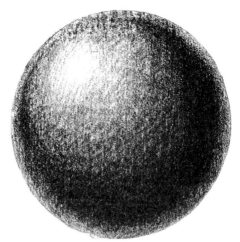

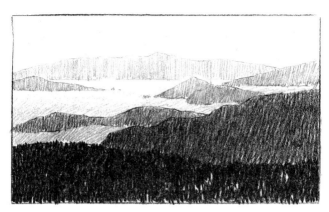

Aerial perspective
A sense of depth and distance is created through the progressive lightening of tones in a scene as it recedes toward the horizon.

Tone and composition
The strongest contrasts between light and dark create interest and draw the eye, so they are placed around the boat, which is the main focus of the picture. The strength of tone and degree of contrast is reduced elsewhere, to avoid competing. The boat has been placed well off-center, but is balanced by the shape of the foliage on the river bank.

Modeling a sphere and cone
Spheres and cones have gradually curving surfaces, and are modeled through smooth gradations in tone. The progression from light to dark creates the impression of a solid, rounded object. The reflected light on the opposite side to the highlight on each form is essential for conveying a fully three-dimensional effect.

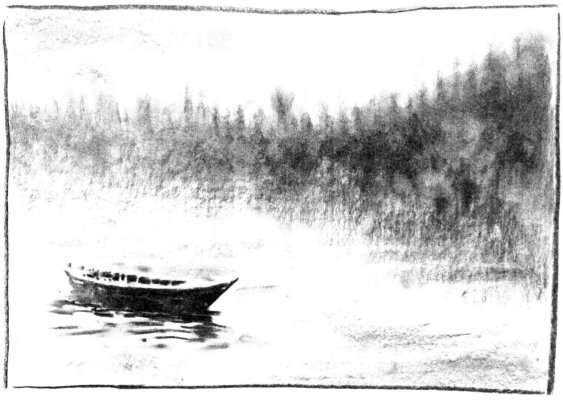

Crosshatching

Crosshatching is a way of building up areas of tone to describe forms and light. Many layers of hatching can be built up in different directions to create a surface that has great depth and a rich, textural feel. It can be done with a wide variety of media, and in a precise or loose style.

Crosshatching is done by drawing short lines parallel to each other in one direction, and then drawing a second layer over the top at an angle to the first. You can go on building up more lines in different directions until you have the desired depth of tone. One of the advantages of this technique against solid areas of tone is that, because the lines are laid down with gaps between them, however many layers you build up there will always be little specks of white paper showing through, which creates great luminosity.

Crosshatching can be done with any media that will draw a line – pencils, pens, ballpoints, crayons, fine brushes. Chalks and pastels can be used on their corners, or brought to some kind of point. It can be done in a formal, structured way or a loose, scribbly way, according to your own style and approach. Try some different styles, letting the areas of hatching develop loosely across the sheet of paper.

You can vary the weight and density of areas of crosshatching according to the medium you use and how widely you space the lines. Heavy lines closely spaced will create a dense surface, whereas light, widely spaced lines will create a lighter effect. It is best used on smooth and semi-rough papers, because a very

rough surface breaks up the hatching lines to the point where they cease to be effective.

Crosshatching can look stilted and unnatural when you first try it. The best way to get over this is to take a sheet of paper and experiment, letting patches develop freely across the paper, varying the weight and angle of the lines, and the spaces between lines. Then try drawing simple rounded shapes, such as apples and pears, gradually building up the tone in the shadow areas to create a sense of three-dimensional form.

Variety of media
Crosshatching can be done with any materials that make a line, from thick to fine, and can be adapted to suit your own style.

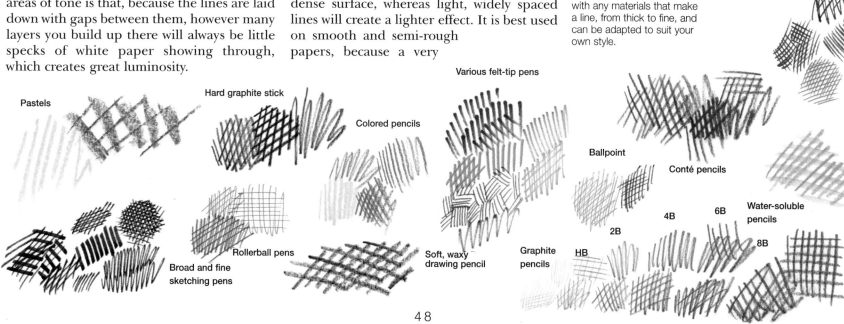

Pastels

Hard graphite stick

Colored pencils

Various felt-tip pens

Steel-nibbed pen

Ballpoint

Conté pencils

Water-soluble pencils

Broad and fine sketching pens

Rollerball pens

Soft, waxy drawing pencil

Graphite pencils

HB 2B 4B 6B 8B

Varying the direction of the surface
Crosshatching done with straight lines laid over each other at right angles produces a flat surface. You can alter the density and overall tonal impression by varying the thickness of the lines and the gap between them.

If the crosshatched lines are curved, they will create the impression of a curved surface, and by altering the angle at which the lines are laid over each other, you can increase or decrease the degree of the curve.

By altering the direction and angle of the hatching across an area it is possible to produce the effect of a surface that changes direction. By making the angle more acute and gradually drawing the lines closer together, you can create the impression of a surface receding into the distance.

Modelling form
LEFT Crosshatching can be used to describe a gently curving form by building up the tone gradually from light to dark as the surface turns away from the light. Start with hatching in one direction over the whole form, breaking it where the highlight falls. Lay another layer at a different angle over all but the lightest area, another over the darker areas and so on, until you have the depth of tone of the darkest shadows.

RIGHT Crosshatching can also be used to create sharp contrasts in tone to describe abrupt changes in direction between one surface and another, such as the lit top side of the folded cloth against the dark side away from the light. The direction of the hatching lines follows the curving forms of the cloth, and the lines are always made at an angle to the surface being described, not parallel with the edges.

Gestural Marks

There are no hard and fast sketching rules, and there are all kinds of alternative instruments that you can use for drawing. Once you have grown accustomed to your basic range of materials, you may wish to experiment with some less conventional methods and materials. Pencils and chalks can be used in unconventional and highly expressive ways, too.

You can make your own materials. Homemade reed pens can be shaped by cutting the end to a point with a craft knife, to be used with drawing ink. They do not last very long, but are a quickly made and cheap drawing tool that can produce varied and characterful lines and marks that respond to changes in pressure and direction.

Matchsticks and toothpicks, again used by dipping in ink, can produce expressive marks and lines, and may be combined with pen and brush marks and washes.

Finger drawing may not be an obvious approach, but can produce highly expressive and sensitive drawings, either used independently or combined with other media. Inks and paints are obvious media to use with finger drawing, but it also works well with powdered charcoal or pastels. A variety of lines, blobs and more solid patches of colour can be produced, as well.

Blots can be drawn or dropped on to wet or dry paper and then manipulated with brushes or matchsticks. An interesting exercise is to make an initial random pattern in this way and see what subject it suggests to you, and develop the drawing from there.

With these approaches don't try to describe the subject in a detailed way. They are better suited to indicating your mood or response to the subject through a wide range of marks – squiggles and swirls, smudges, blots and blobs, all kinds of linear marks, rubbing out, dots, dashes and scribbles. These drawings should be quick, spontaneous and energetic, and done without too much thought or deliberation.

Finger painting with watercolour

Graphite stick

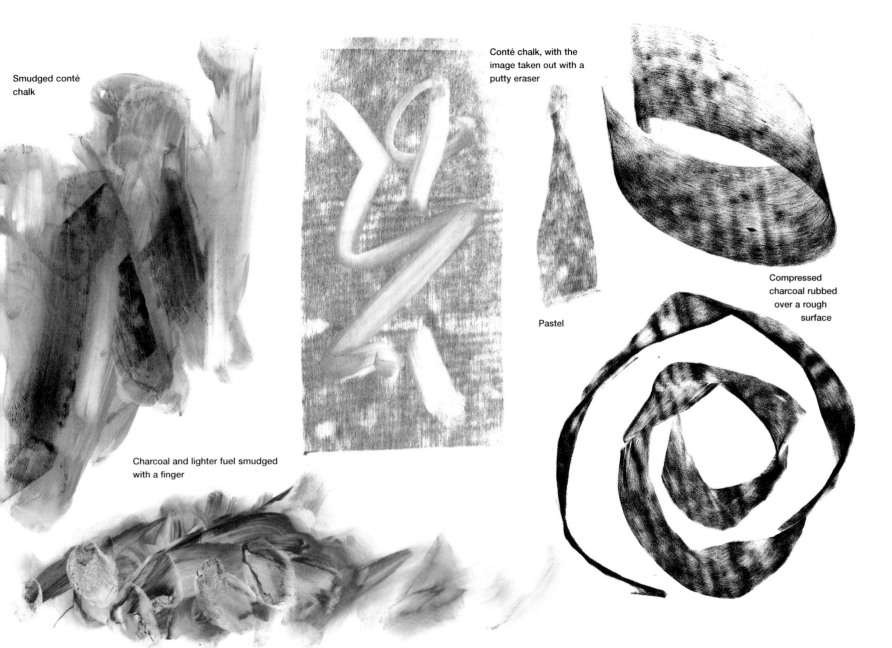

Smudged conté chalk

Conté chalk, with the image taken out with a putty eraser

Pastel

Compressed charcoal rubbed over a rough surface

Charcoal and lighter fuel smudged with a finger

Colour Theory

An understanding of the basic characteristics of colours will enable you to use them in a satisfying way. The specific qualities of colours – whether they are harmonious or contrasting, bright or dull, warm or cool – can be used to create specific effects.

Colours have three qualities – hue, tone and brightness, also known as intensity (sometimes also called chroma). Hue refers the actual colour – red, blue, green and so on. Tone refers to the colour's lightness or darkness. Brightness or inten-sity refers to the degree of saturation or mut-edness of a colour.

The best starting point for a basic understanding of colour is the colour wheel, in which the primary and second-ary colours are arranged in a cir-cle. The primary colours are red, yellow and blue. They are so called because they cannot be mixed from other colours. The secondaries are each mixed from two primaries: red and yellow pro-ducing orange, yellow and blue pro-ducing green, red and blue producing violet.

The pairs of colours that are opposite each other on the wheel – violet and yellow, red and green, and blue and orange – are known as complementary pairs. When complementary colours are mixed together they produce some neutral form of grey or brown, whereas, put side by side, they will enhance each other. Colours that are next to each other on the wheel are described as harmonious, and provide a way of introducing variety of colour without creating a contrast.

Colours are also described as warm or cool, although these are relative terms: a colour is only warm or cool in compari-son to another colour. Warm colours are those on the orange/red side of the wheel, and cool ones are on the blue/ green side, although, if you compare two reds, for example vermilion and permanent mag-enta, the vermil-ion, which is quite an orange red, will appear warmer than the magenta, which has some blue in it and leans towards violet.

Primary and secondary colours
The basic colour wheel in the centre shows the relationship between the primary and secondary colours. The secondaries are each mixed from two primaries: orange from yellow and red, violet from red and blue, and green from blue and yellow.

Tertiary colours
When an adjacent primary and secondary colour are mixed, they produce a tertiary colour, illustrated on the outer circle: green and yellow produce yellow-green, yellow and orange produce yellow-orange, red and violet produce red-violet and so on. In this way a wide range of colours can be mixed from the three primaries.

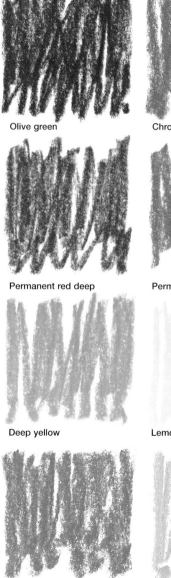

Olive green

Chrome green deep

Permanent red deep

Permanent rose

Deep yellow

Lemon yellow

Ultramarine deep

Phthalo blue

LEFT There are warm and cool versions of hues. Olive green tends towards yellow so looks warmer than chrome green, which tends towards blue. Permanent red deep appears warmer than permanent rose, which contains a lot of blue. Deep ellow tends towards orange, and appears warmer than lemon yellow, which tends towards blue. Ultramarine tends towards red so appears warmer than phthalo blue, which tends towards yellow. A colour can look warm against one colour and cool against another. Olive green looks cool against deep yellow but warm against permanent rose.

ABOVE LEFT Complementary colours are directly opposite each other on the colour wheel. The complementary of red is green, of blue is orange, and of yellow is violet. The tertiary colours also have complementaries: the complementary of yellow-green is red-violet, of blue-green is orange-red, and so on.

ABOVE Harmonious colours are next to each other on the colour wheel and are similar in hue.

RIGHT A colour can vary from light to dark, and also from saturated to dull.

Colour Mixing

It is much better to mix the precise colours you want than to make do with ready-made colours from your pencil or paint box. Mixed colours will contain variation and vibrancy, whereas areas of single, unmixed, colours can appear dull and flat. Colour mixing is easier with paints and pastels than with colour pencils or felt-tip pens. Paints can be blended on the palette until you achieve the exact colour you want before applying it, and pastels can be blended on the paper. With some drawing materials, thorough mixing can be difficult, although there are methods of mixing where individual strokes or patches of colour are either put down side by side or laid over the top of each other in such a way that all the colours are visible and mix in the viewer's eye. This is known as optical colour mixing, and is particularly suitable with such media as colour pencils.

Optical mixing can produce some vibrant and exciting colour effects. If you haven't ever tried these techniques before, the results may seem rather over-dramatic and unsubtle at the out-set, but if you continue with them throughout a drawing, developing interesting colour mixes, building up and adjusting them as necessary to provide dense areas of modulated colour, then the effects can be very successful. Experiment with methods and colour mixtures, and remember to stand back from your work to assess the results, as the effect will be quite different if you are standing close and can see all the individual marks, than if you are standing a few feet away, where the colours will all appear to merge together.

Pencils and pastels can be applied next to or over each other and smoothly blended, or hatched and crosshatched. With transparent media such as watercolours and thinned-down acrylics, one colour can be laid down over another dry colour so that they mix optically. Optical or broken colour techniques include scumbling one colour roughly over another, and pointillism, in which dots of different colours mix in the viewer's eye.

Heavy blending with colour pencils

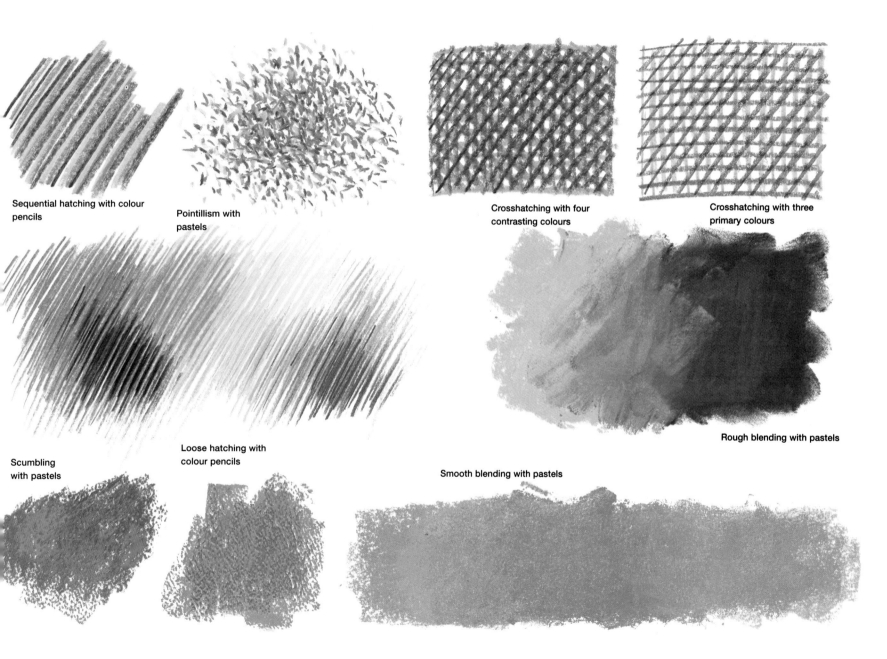

Sequential hatching with colour pencils

Pointillism with pastels

Crosshatching with four contrasting colours

Crosshatching with three primary colours

Scumbling with pastels

Loose hatching with colour pencils

Rough blending with pastels

Smooth blending with pastels

Colour Mixing 2

A basic palette of colours that includes warm and cool versions of each of the three primaries would be: lemon yellow (cool) and cadmium yellow (warm), cadmium red (warm), alizarin crimson (cool), ultramarine blue (warm) and cerulean blue (cool). These colours will enable you to mix a wide range of intermediate colours, so if you base your selection on versions of these colours, whatever materials you are using, you will have the maximum flexibility for colour mixing.

Greys and browns
A whole range of vibrant greys and browns can be produced by mixing complementary colours – blue and orange, violet and yellow, and red and green. These mixtures will be much more interesting than greys made from black and white.

Greens
It is better to mix greens from other colours than to use ready-made ones. If you are using pencils or felt pens that cannot be mixed, give variation to areas of green by adding in colours such as yellow-greens and blue-greens. Touches of earth colours will warm up an area of green. A wide variety of greens can be mixed, from warm olive-greens to cold blue-greens, and from green-greys to vibrant acid greens. They can be mixed from yellow and blue, warm yellows giving a warm green and cool yellows a cool green. Viridian is the one green that is useful to have in your palette. It can be mixed with lemon yellow for a sharp green, with blue for a cool green, and with earth reds for a warmer green.

Darkening a colour
Good ways to darken a colour are either to mix it with a similar but darker colour, or to mix in a little of its complementary.

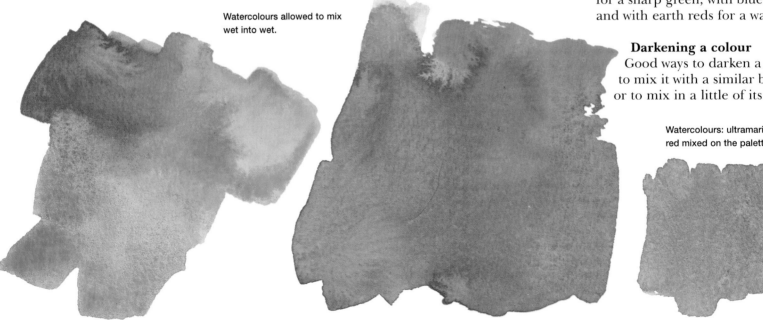

Watercolours allowed to mix wet into wet.

Watercolours: ultramarine blue and cadmium red mixed on the palette.

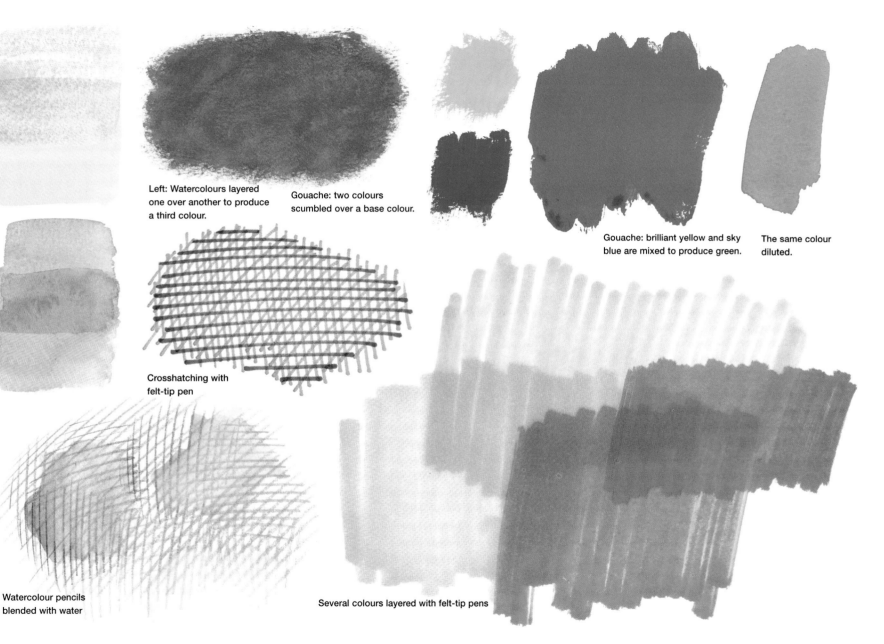

Left: Watercolours layered
one over another to produce
a third colour.

Gouache: two colours
scumbled over a base colour.

Gouache: brilliant yellow and sky
blue are mixed to produce green.

The same colour
diluted.

Crosshatching with
felt-tip pen

Watercolour pencils
blended with water

Several colours layered with felt-tip pens

Using Colour

There are many ways in which to experiment with colour. It can be handled descriptively, using accurate observation and mixing the colours seen. It can be used primarily to model form and create a sense of three-dimensional space. Or it can be used in an entirely expressive and atmospheric way.

When recording the colours you actually observe in a subject, ask yourself whether they are light or dark and warm or cool. Pay particular attention to areas of highlight and shadow, and look for the reflected colours from other objects.

Out of doors, shadow areas usually contain blue, so tend to be darker and bluer versions of the parent colour. Subjects lit by artificial light may contain warm shadows.

If you want to use colour to express a particular atmosphere or sense of place, it is most effective to use a limited palette of four colours – use a version of each of the primaries, plus an additional earth colour or a green such as viridian, plus white. For a warm scene, choose predominantly warm colours, and for a cool scene use cool colours, but always include a contrasting note to set off the predominant mood. A limited palette will also allow you to work in a range of more neutral, subtle, mixed greys, while providing for touches of bright colours here and there.

Warm colours placed near cool ones tend to advance in a drawing, and cool colours recede when seen against warm ones. This is a useful way of creating a sense of space receding into the distance. Space can also be conveyed through the contrast between bright and muted colours. Bright colours will tend to advance and duller or muted colours will recede (unless used in the foreground).

Realistic colour
Colours have been used that record the actual types of colours that are seen in the landscape.

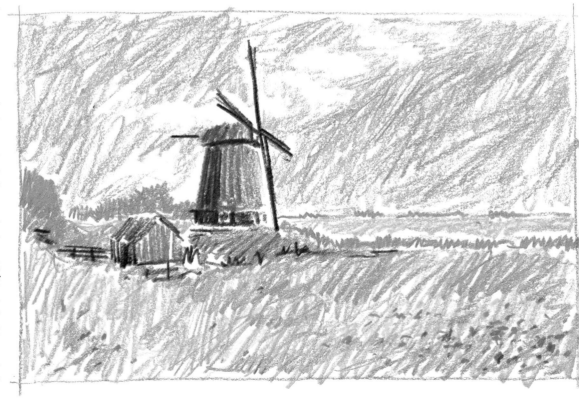

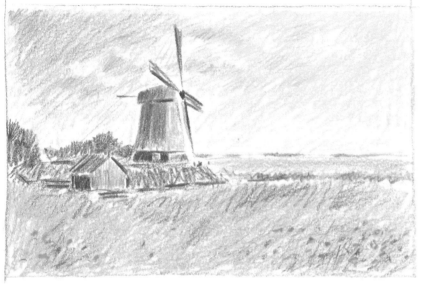

RIGHT Progressively cooler, paler blue-greys are used in the distance.

BELOW Bright blue-greens and yellow greens are used in the middle ground.

Atmospheric colour
A small number of predominantly warm colours have been used that do not relate to the actual colours seen in the subject. Instead they convey an atmosphere of intense warmth and light.

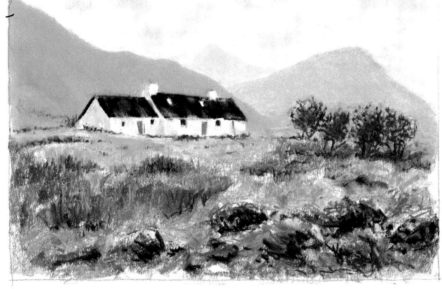

Colour and recession
Colours in the distance often look cooler and more muted than those in the foreground. This will create a sense of spatial recession in a drawing.

ABOVE Warm, strong, bright colours are used in the foreground.

Sketchbook Work

Regular, quick sketching is a vital aspect of the development of your drawing skills. Carry a sketchbook with you at all times, then whenever you feel the urge to make a quick sketch, you can simply open it up and get to work, whether you have five or fifteen minutes to spare. Sketchbooks also have a value in that they can provide an interesting record of places, people, events and activities, as well as a diary of your own history and development as an artist. In addition, sketches and notes provide useful reference material for paintings and studio drawings to be put together at a later date.

Think of a sketchbook in the same way as a diary: there is no need to show the contents to anyone if you don't want to! It is an ideal place for experimenting with approaches and techniques and for trying out compositional ideas or different ways of recording information. You don't need to worry about composition, and you can work over or overlap drawings. You can always cover up something you don't like with another drawing, so don't feel inhibited. A sketchbook is ideal for working out of doors, or in public, as it is far more discreet than a large sketch pad or drawing board sitting on an easel.

Sketchbook work is also a good way to explore particular types of subjects

in depth, and the better you get to know a subject through drawing it, the more convincing your drawings of that type of subject will be. Choose a subject that interests you – people, boats, plants, bridges, buildings, skies or whatever else takes your fancy. If possible, select a subject that you know something about, as prior knowledge of it will inform your drawings and make it easier for you to analyse the subject with confidence. Sketch your chosen subject at every opportunity, at different times of year if it is outdoors, and in different circumstances and settings, so that you build up a real store of understanding and visual knowledge about it.

A sketchbook is the ideal place to make quick studies of scenes and people and to experiment with new ways of using materials.

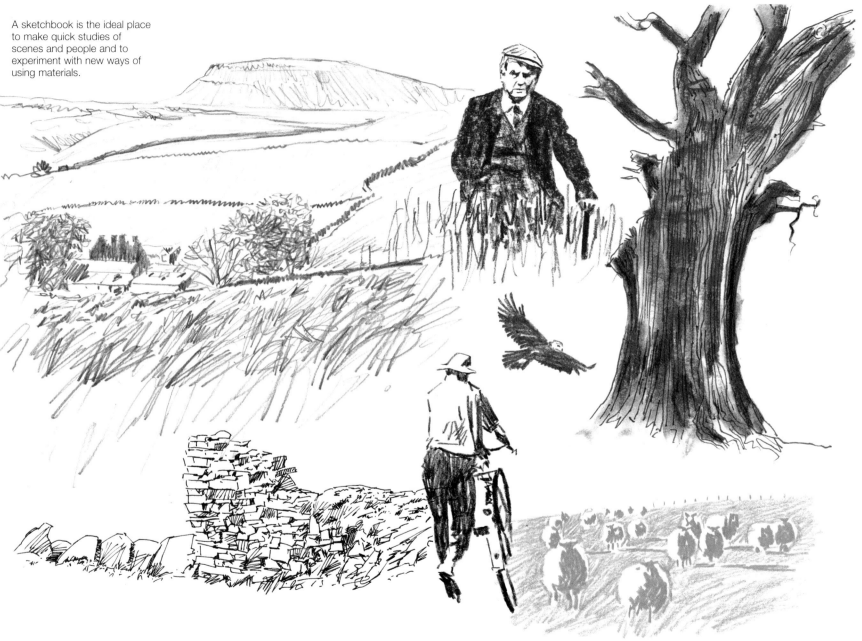

Gathering Information

Sketchbooks are ideal for recording lots of information about a particular subject or place to use at a later date in the development of full-scale paintings and drawings.

A useful exercise is to select a place – it could be a building, an area of a town, or a particular landscape – and record as much information as you can about different aspects of it. Begin with quick drawings from various viewpoints to help you assess which aspects of the subject have strong compositional elements. These will also help you understand the forms and structures within the subject, and to decide how much to include if you go on to make a more finished drawing. Next, make a charcoal or soft pencil drawing to record the subject's tonal pattern.

The colours can be recorded either in separate colour sketches made with colour pencils or pastels, or with colour washes over a line drawing, or colour swatches, or written notes. Record the date, time of year, time of day, weather conditions and the direction of the light as a reminder for later use. Small drawings of specific details, patterns and textures within the subject add interest, and may also be useful later. It is surprising how one often doesn't have enough detailed information for larger works.

This kind of material can provide a wonderful and very personal record of a place, or even a journey or a holiday, valuable in its own right, even if you aren't planning to use it for a drawing or painting later. Additional material such as postcards and photographs, and found objects like leaves or grasses, can be stuck in for later reference.

Working out of doors

When sketching out of doors, work quickly and complete what you want to do in one session. You will probably need to do this anyway because elements in the subject, such as people, the sky and effects of light and shadow, will be moving and changing. If you feel you haven't got the best out of a subject, make as many sketches as you need to in order to capture the effect that you want. Don't allow yourself to be distracted by people who come up to look at what you are doing. Once you get going, you probably won't be aware of them anyway.

Information for paintings

A sketchbook is the best place for making studies of a subject that can be used for a more considered drawing or painting back home, as you will have all your reference material in one place. As well as an overall drawing of the subject, record information on colours, tones and textures, the structure of any complicated areas, and details. The artist has recorded the overall subject and made compositional and tonal notes. Information is included on tricky details, such as the patterns created by light reflected in the windows, the structure of the tiles and the pattern in which they are placed on the roof, and the colours present in areas such as the brickwork and roof.

A study of the light reflected in the windows

A tonal sketch of the roof tiles

Colour notes for the wall

A compositional sketch in three tones

A tonal sketch of the shadow area

A colour study of the roof tiles

A detailed study of the pattern of the tiles on the roof

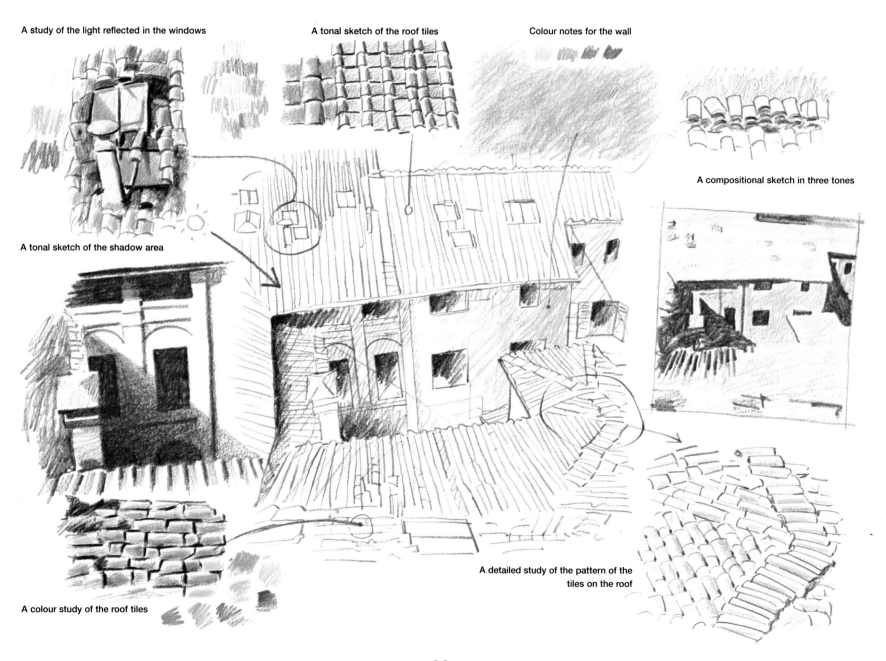

Texture

The best way to capture textures is to think in terms of the textures that can be created with different media. It is possible to draw the fur on an animal with a fine pencil, for example, but a much more suggestive and interesting effect can be created by working in a medium such as gouache and dragging a brush loaded with dryish colour over an area of wash or solid colour. Pebbles on a beach can be drawn or painted, but they can also be created by spattering the paper with paint using a stiff stencil brush or an old toothbrush. A smooth, reflective surface can be conveyed through blended tonal contrasts and modulations done in pencil or charcoal.

The nature of the paper surface can also enhance or hinder textural effects. Smooth textures are continuous, so if your subject includes predominantly smooth surfaces you would be best to work on a smooth paper. If you are using a rougher paper, make sure that the medium is worked into all the pits in the surface. Rough-textured surfaces are uneven and broken, so will help in creating the textured effects with pencils, chalks and so on, which can be dragged across the paper on their sides to create a broken effect. Soft surfaces may be rough or smooth, but being soft and giving, they undulate with dips and folds. With water-soluble media – pencils,

paints or even soft pastels – soft textures can be described by working on to damp paper, creating a diffused effect.

If the textures in your subject are predominantly of one type, touches of other textures should be included, partly to add interest, but also because an effective way of emphasizing the texture of things is through contrasts with other textures.

The degree of texture that is apparent in a subject will decrease with distance. This should be reflected in your drawings if you are not to negate effects of space and depth that you have created through other means, such as perspective or diminishing scale.

Pastel on paper over
coarse sandpaper

Irregular and regular patterns with graphite stick

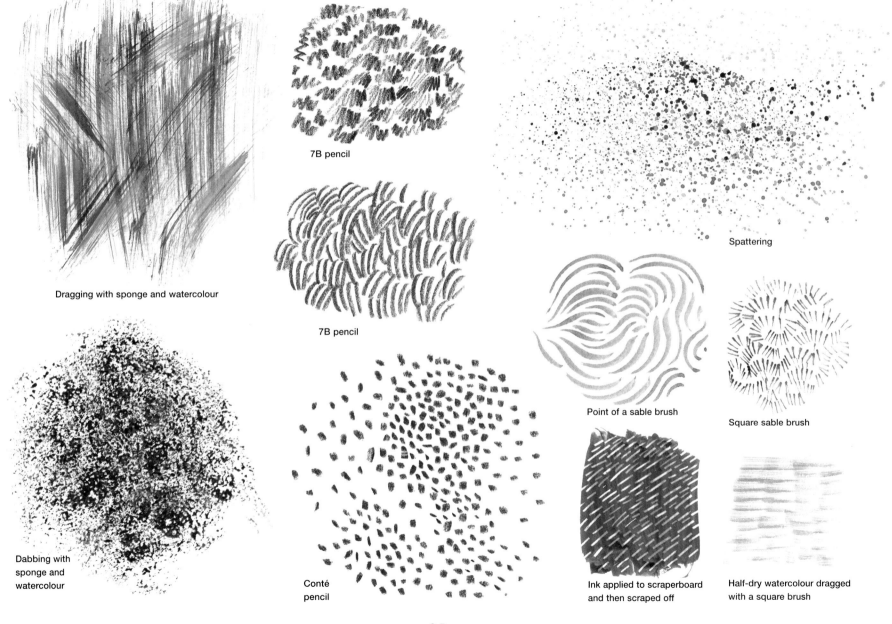

Dragging with sponge and watercolour

7B pencil

7B pencil

Dabbing with
sponge and
watercolour

Conté
pencil

Spattering

Point of a sable brush

Square sable brush

Ink applied to scraperboard
and then scraped off

Half-dry watercolour dragged
with a square brush

Moving Subjects

Capturing and conveying movement is not as difficult as it may initially seem. Certain techniques are very effective, and, if the moving object is contrasted with static elements, this will add to a sense of movement. Don't try to capture accurate details. The sweeping, fluid lines made as the hand moves quickly across the paper are essential elements when you are generating a sense of movement.

Movement in a person or animal affects the distribution of weight and balance of the whole body. One way to suggest that a figure is in the process of moving is to draw it in an off-balance position. As an extreme example, think of drawings or photographs of dancers or athletes in action. In such images, movement is conveyed by the fact that they could not possibly remain in the position in which they are portrayed without falling over. As a result, the eye tends to read such images as signifying movement.

When we look at moving people, we see the head and shoulders fairly clearly and the legs as a blur. Again, this is the clue to drawing them. Blurring and smudging are quick, effective ways of suggesting movement, as are a mass of fine lines creating a blurred outline.

For subjects such as water, or quickly changing light, study the pattern of light and dark tones, or look for swirling directional lines, and concentrate on capturing these effects. Whatever the subject, you need to pick a moment and stick to it, regardless of subsequent changes.

Scenes that contain continuous movement – such as markets and fairgrounds – can be quite bewildering to the beginner, but there is a useful strategy for dealing with such subjects: first draw the setting. Only then study the people as they come and go. However far away figures might be, if the ground is flat, their eye level approximately coincides with yours, allowing for differences in height. This is the key to putting in figures quickly in the correct scale. First record the position of a person's feet in relation to fixed elements, such as buildings, and then put in the rest of the figure with their heads approximately on the eye level. Groups tend to form and reform in the same places again and again. Notice where this happens and construct the groups as individuals come and go.

Speed
The image dissolves into speed lines.

Off-balance
From the way the body is balanced it is obvious that the figure is moving.

Out of focus
The spots on the cheetah's fur are blurred and the legs are almost lost, producing an impression of extreme speed.

Blurring the action
It is enough to blur the legs and feet in order to suggest movement.

A busy scene
First establish the eye level and draw in the fixed elements – here the street with the buildings on either side. As people move about, plot where their feet are in relation to doorways, paving stones and other fixed elements. Then establish the position of their heads on the eye level in order to draw them in the correct scale to each other and the scene as a whole.

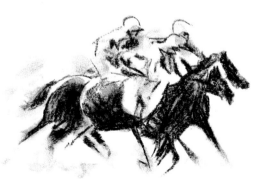

Mixed Media

There are no rules about mixing media, that is, combining more than one kind of drawing or painting medium in a single picture. There are lots of ways that you can approach mixed-media work. Sometimes, you may start out with one medium, then add in a second, and possibly a third, at later stages if and when they are needed, to create a special effect or to reinforce some quality that is not quite working. Alternatively, you can plan the use of a range of materials from the start, to give texture or contrasts in colour, tone and quality. Mixed media can also provide a way to rescue and enliven a drawing that is a little dull or overworked.

When planning a drawing that combines different media, think in terms of the compatibility of the materials that you want to use. They should complement or contrast with each other in some intentional way, such as line with a wash, which substantiates the drawing through solid areas of colour or tone. Or concentrate on materials that produce textural effects or contrasts, such as soft or oil pastels over paint on a medium or rough paper; or strong colour contrasts, such as the soft colours of watercolour or gouache and the vibrancy of pastels.

Incompatible materials are those where one would completely overpower the other – conté chalks and felt-tip pens for example, or pencils and felt-tip pens.

Washes give a feel of solidity or of a continuous surface, and line can be used to redefine drawn elements that are either missing or which have got lost under the wash. Pen and ink over pencil can reinforce or redefine elements, or you can incorporate it to introduce stronger, darker touches that will stand out from a complex background. Points of bright colour can provide the focus in a drawing, or they can be used to introduce a textured feel to the surface.

Transparent and opaque media can be set off against one another, as can different textures, and light can be created through strong tonal or colour contrasts. When combining several media, continue to use each for the aspect of the drawing to which it is best suited: pen or pencil for the initial drawing and for restating any areas that need strengthening after the other media have been applied; paint for blocking in the main areas of the composition; and colour pencils or pastels for adding touches of intense colour.

Charcoal and pastel
Charcoal and pastel are both soft, easily blended media that combine well with each other. Apply charcoal first, lightly, and when pastel is added over the top the two will merge to produce interesting dark tones.

Coloured pencils
Soft and hard coloured pencils can bring different qualities to a drawing: hard pencils giving rich, strong areas of colour, the soft ones fine lines and more subtle colours.

Charcoal and acrylic
Charcoal and acrylic paint can be combined to create rich, dense areas of tone and colour. The charcoal can be blocked in under areas of paint to provide depth of tone and texture, or it can be used to introduce line.

Watercolour pencils
Watercolour pencils can be used to work with line and washes of colour without switching medium.

Pencil and pen and ink
Ink lines drawn with a sketching pen reinforce the form of the car, which has been blocked in with pencil.

Mixed Media 2

Two mixed-media techniques that are effective and easy to master are line and wash, which combines a linear medium with washes, and wax resist, which combines oily or waxy crayons with water-based paints.

Line and wash

Line and wash work offers you a whole range of additional sketching possibilities. It is a particularly interesting method that combines both line and tone in one drawing. Because they can work together and independently of each other at the same time, the effects that lines and washes produce are more varied than those you can achieve with a single medium. Either the line drawing can be made first, and the washes added over the top, or the washes can be laid down first with the lines added later. Whichever way you work, these methods can provide a very useful way of working.

Do not use line simply to draw outlines. Lines and linear marks can describe structure, texture and details, and suggest movement in the same way that a line-only drawing can. Either single-colour washes in a small number of tones, or a limited number of colours – about three or four – can be used to give substance to a drawing.

Line and wash
Warm, subtle washes are used in two lightish tones to give solidity to the onions, and the blue wash provides shadow in the background.

Whether you are working with tone or colour, the best approach is to put on broad areas of wash. With tone, think in terms of describing the light, mid and dark tones, massing together the intermediate tones into big areas. If you are working with colours, use them to map either different main elements in the subject, or light and shadow areas, or to map the foreground, middle distance and sky in a landscape scene. Whichever approach you take, keep the washes fresh and simple.

Wax resist

Wax resist techniques depend on the fact that both wax and oil repel water. Wax crayons and oil pastels can be used with any water-based medium, such as watercolour, or marker pens. Apply the crayon or pastel first. When you apply washes over the top, they will run off the wax or oil areas, revealing the colour underneath. You can use light tones over dark or dark over light, and either harmonious or contrasting colours.

This technique is very unpredictable, which is part of its appeal. Don't try to control the result too much, but let random effects occur and then build on them once they have settled and the paint has dried.

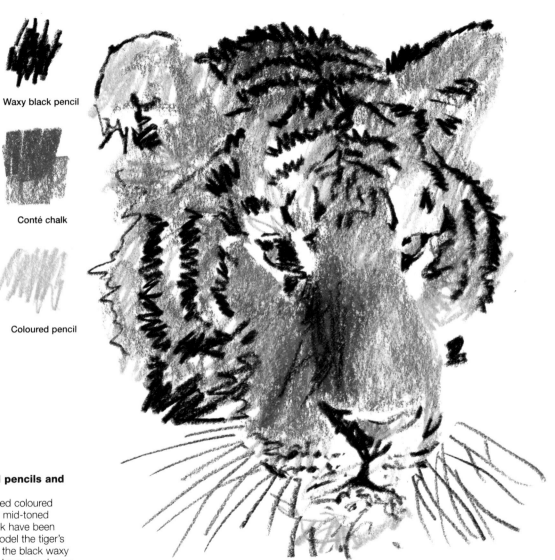

Waxy black pencil

Conté chalk

Coloured pencil

Line and wash
Ink lines define the glass
and grapes, and the
washes describe the liquid
in the glass, with reflected
colours on the rim and
base. The paper has been
left white in places for the
highlights.

**Coloured pencils and
chalks**
A light-toned coloured
pencil and mid-toned
conté chalk have been
used to model the tiger's
head, and the black waxy
pencil has been used over
the top to reinforce the
features and describe the
pattern in the fur.

71

Preparing Paper

If you are going to use water-based techniques such as colour washes and paints, you will have to stretch the watercolour paper first, because when paper is wet, or even damp, it stretches and buckles. This is not only irritating, but it can damage your painting, too. The principle of stretching is that you wet the whole sheet of paper, tape it down and let it dry, so that it is fully stretched when you work on it and shouldn't buckle any more. It is an easy process and it is worth stretching several sheets at once.

You will need: a board for each sheet of paper at least 5 cm (2 in) larger all round than the paper; lengths of gumstrip, about 5 cm (2 in) wide and a little longer than the sides of the paper (don't try to use masking tape as this won't adhere when wet); a sponge and a bowl of water. Soak the paper in a bowl or bath; remove it and let the water run off; then lay it on the board and smooth it out. Wet the strips of tape with the sponge and position them along the sides of the paper, allowing a good overlap over the paper, and press

down firmly. Leave the board lying flat while the paper dries. If it is vertical, the water will drain down to the bottom edge and the tape on that side won't adhere.

Watercolour washes and other paint techniques can be applied to stretched paper to provide interesting coloured or textured backgrounds to work on. They can also banish the inhibitions caused by pristine white paper. Gouache, which is opaque, gives a good background for materials such as pastels. Paint can be sponged or spattered on to paper, which can create interesting areas of

Watercolour sponged on to paper

texture in the subsequent drawing. The wax-resist method can be used with a rough-textured paper. Apply oil pastel over the paper, and then add a watercolour wash of a different colour or tone over that. The watercolour will take in the pits in the paper left unaffected by the oil pastel to provide a luminous colour background.

For maximum interest and impact, incorporate these background effects into the drawing, using them in a similar way to the background colour or tone provided by coloured papers.

Watercolour applied and sponged off

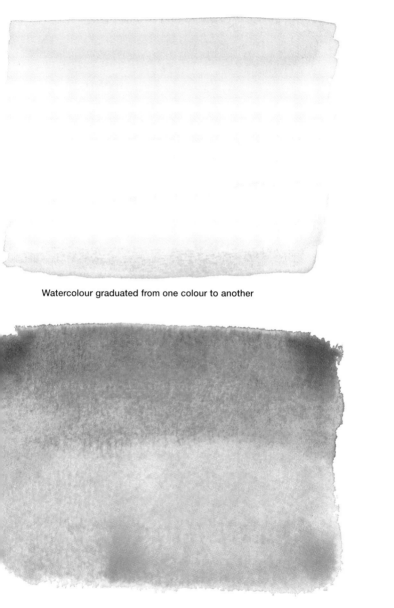

Watercolour graduated from one colour to another

Opaque ground in acrylic paint

Spattered gouache

A variegated watercolour wash using three colours

A variegated watercolour wash using warm and cool colours

A flat watercolour wash

Projects

The twelve very different and exciting projects in this section make use of
the many and varied materials and techniques outlined in the previous
sections. Wherever your interests lie – in drawing skies or water, the human
head or whole figures, street scenes full of people and activity, flowers or
still life – the projects will provide you with plenty of information and
inspiration for getting started. Some involve working out of doors, in
front of the subject, while others can be tackled at home, and all
provide a good basis for continuing to work on your own.

Introduction

The techniques covered in the previous section will stand you in good stead when you tackle the projects. Each one explores different materials and helps to illustrate just how you can put the techniques described in the previous section into practice. They also introduce you to different types of subject matter – such as still life, landscape, interiors and figures – and demonstrate the wide range of approaches that you are free to take.

The projects cover: drawing with line and with tone, using atmospheric and observed colour, pen and ink, line and wash, sketching in watercolour and combining different media. Each project also introduces facets of picture-making – such as creating space, contrast through tone and colour, conveying movement, creating atmosphere, using shape and pattern to create a strong design – that will give your sketches more impact and interest.

Some of the projects are presented as step-by-step sequences to illustrate how a particular technique is used to build up a drawing, while others include information on materials, techniques or composition specific to that project, that will enable you to carry it out on your own. It is best to find or set up your own versions to work from, rather than copying them from the book, as it is important that you work from

your own observations of the subject. Use each project as a starting point for your own work, and find out which kind of materials and subject matter and which ways of working – indoor or outdoor, planned or spontaneous, from direct observation or using sketches to create a more complex composition – suit you best.

If you feel that your first attempts are not very successful, don't be disheartened. You can make as many drawings as you want of the same subject. As has been said already, practice is needed to develop your powers of observation and your handling of materials. In addition, the better you get to know a subject, the better informed and more convincing your drawings will become.

Every artist wants to develop a style of their own, but this is not something that can be forced. It comes through actually making lots of sketches, and through studying the work of artists whose pictures you particularly enjoy and find interesting. Examine the materials they may have used and the ways in which they have used them – not so that you can imitate what they have done, but to get ideas for techniques that might suit what you want to do. Also, keep all your sketches and look back through them from time to time. This will not only give you a sense of your own progress and artistic development, it will also enable you to identify the preferences in materials, techniques and ways of drawing that recur in your work, so that you can build on them in order to develop your own approach to subject matter and ways of using materials.

Before you start a sketch, always ask yourself why you are doing it – in other words, what interests you about that subject – and concentrate on bringing out those qualities in your drawing, even if this means leaving out other aspects that don't fit with what you want to convey.

Don't slog away with a particular type of subject or approach just because you think it's something that you ought to be able to do. Work out what you do well and what particularly interests you and concentrate on developing your skills in those areas. Sketching should be fun – something you enjoy, not too much like hard work!

Pair of Shoes

Line and Tone

There are two fundamental approaches to choose between when you are starting out: line and tone. With line, form and volume are described by purely linear means; with tone, they are described though the interplay of light and shadow. By making two drawings of the same subject, you can begin to explore the differences between these two approaches.

Choose an everyday object with a reasonably simple shape and place it on a plain background with the light striking it from one side.

You can use colour materials such as pastel pencils, or graphite pencil, but pastels and charcoal are not good for the line drawing. You needn't use exactly the same materials for both drawings. In the demonstration, pen and ink are used for the line drawing and conté chalk for the tonal one. It is better to avoid colour pencils, as they are quite soft and you may find them difficult to use for line work until you have got used to them.

When drawing with line, try using it to describe where the edge of one surface meets another, rather than drawing outlines. To give an impression of the volume of an object, you need to provide information in the drawing to suggest that this is so. If you just draw outlines,

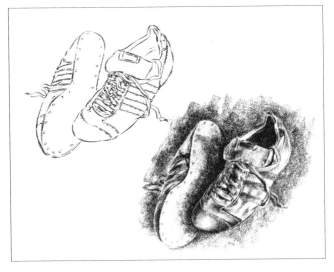

this will result in a drawing that looks flat. To provide the necessary information that the form is three-dimensional, let the line travel across the surfaces of the object, following their curves, flat surfaces and indentations. Make use of any patterns or lines on the surface of the object itself to help define the object's shape. In this instance, the laces and the stitching are used to capture the irregular shapes and undulating surfaces of the shoes.

For the tonal version, use tone to describe areas of shadow in the object and the background. Study how the object is lit, which sides are illuminated and which are in shadow. Again, don't draw any outlines, but use areas of darker shading to create the shape of the lighter areas, trying to see the subject as a continuously changing pattern of light areas against dark and dark against light. Use your chosen medium on its side to make smooth, continuous, evenly graded areas of tone where surfaces curve and turn. Don't let the shadows cast by the subject become too dark in your drawing, even if they look dark in the subject. If you do, this will emphasize the contours and detract from the sense of solidity that you manage to create through shading.

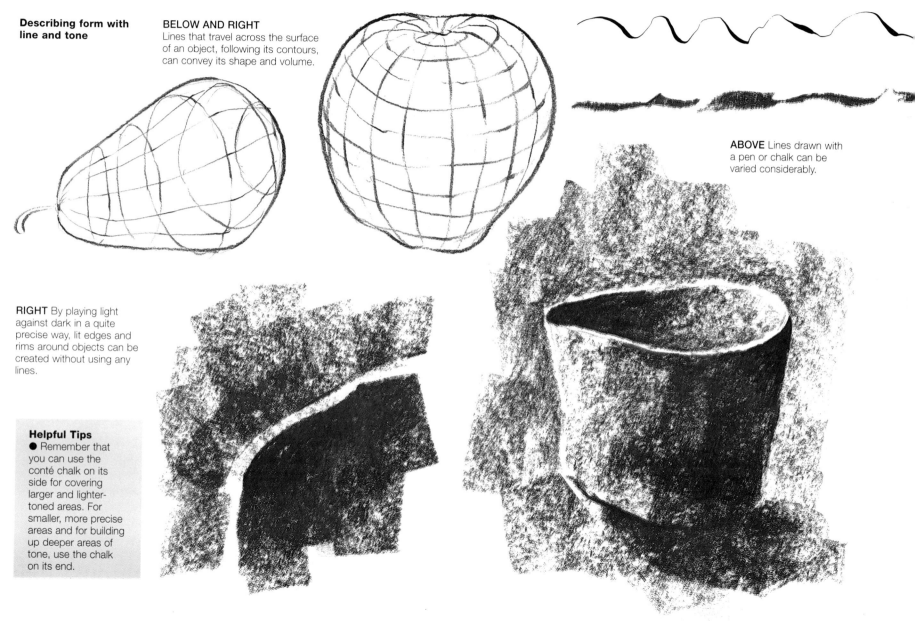

Describing form with line and tone

BELOW AND RIGHT Lines that travel across the surface of an object, following its contours, can convey its shape and volume.

ABOVE Lines drawn with a pen or chalk can be varied considerably.

RIGHT By playing light against dark in a quite precise way, lit edges and rims around objects can be created without using any lines.

Helpful Tips
● Remember that you can use the conté chalk on its side for covering larger and lighter-toned areas. For smaller, more precise areas and for building up deeper areas of tone, use the chalk on its end.

OPPOSITE In the left-hand drawing, lines are used around the outlines to define the overall shapes of the shoes and across the surfaces to describe their form. In the right-hand drawing, tone is used to model the forms. Light is placed against dark to suggest sharp changes of direction between surfaces. Closer tones are used to describe more rounded areas and indentations.

Two ways to create form

ABOVE Lines of stitching are used to describe the rounded form of the shoe.

RIGHT Lines are not continuous, even where they describe a continuous edge. For example, the broken lines along the side of the shoe suggest the play of light and shadow.

ABOVE Carefully modulated tones describe the twisting laces and the holes through which they go, and the lines of stitching without any use of line.

RIGHT The use of shadow defines the edge around the shoe's sole and separates the two shoes.

Still Life

Observation and Use of Line

Still life subjects have the great advantage that you are in control of the subject and the way it is lit, and they offer endless possibilities for exploring shapes and forms, surface textures, light and space.

For this project you will need 2B, 4B and 6B pencils, an eraser and a sheet of cartridge paper attached to a board or in a block or pad. Don't work too small, as this may make you tighten up; it is better to use a sheet large enough to allow you to move your arm freely as you draw.

First set up the subject. You could arrange objects similar to those here, or something different. Still-life drawings are more interesting if they have a theme, so you could select objects that relate to a hobby or activity that you enjoy. Place them on a table-top so that they link up and overlap to form a strong overall shape, such as a triangle. Place the set-up close to its background, which could be a wall or the corner of a room, and avoid very strong light as heavy shadows will conceal too much of the forms.

Study the subject from different angles in order to choose the best viewpoint, then decide whether it should be landscape or portrait

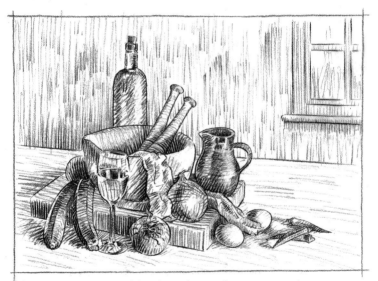

format. Include a little of the background, but the still life itself should occupy most of the paper. Note the shapes between objects and those formed by the edges of the paper – the negative shapes (pages 34–5) – and the shapes formed by shadows, and adjust your position a little if that will make them more interesting.

Begin by plotting the positions of the main objects in relation to each other, and put in the most important features in the background. Then begin on the main forms, noting where one object intercepts another. You can then start to build up a sense of light and solidity.

There are various ways to develop this project further. You could make another drawing from a different viewpoint, studying the changed relationships between objects and the way in which the light falls across the subject in a different way. Or you could take a high viewpoint, looking down on the subject from above, or create a more abstract composition by moving in close so that the set-up completely fills the paper, and letting some of the objects around the edge be cropped off around the sides.

Building up the drawing

1 Once the composition is decided on, the overall dimensions of the still-life group are lightly marked on the paper using a 2B pencil, along with the position of the table-top and structures such as the window in the background. Then the positions and dimensions of each object are plotted in relation to the others. Try to do this by eye, but you can check your observations by measuring with a pencil.

Composition
The objects in this project have been arranged to form a triangular shape, but the highest point is well off centre within the picture area. The objects have been overlapped to create a variety of interesting shapes within the composition and nothing is out on its own. The window in the corner balances the main subject, and fills in what would otherwise be an awkward space.

3 Areas of hatched lines are roughed in to indicate solid surface. There is no need to fill in whole areas with solid shading. Let the hatching follow the direction of different surfaces in order to describe changes of plane within an object.

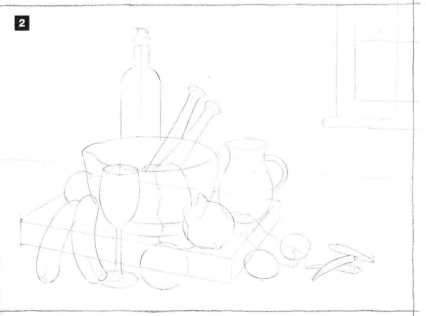

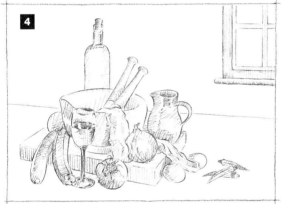

2 The shapes within the composition are built up gradually by moving from one object to the next where they intercept each other and noting the shapes between objects as well as the shapes of the objects themselves. Keep reassessing the drawing, putting in changes without rubbing out the old lines.

4 Areas facing away from the light source are built up with additional light hatching, using a softer, 4B pencil. Hatching lines do not need to keep strictly within the outlines of the shapes, so let them be loose and a little scribbly.

Creating space and light

Even when using pencils and purely linear marks, there are little ways of controlling the feeling of space and the quality of light.

ABOVE Combinations of lines done with pencils of different grades of softness enable you to vary the weight of the line and introduce tonal variety.

Helpful Tips

If any item in the still-life set-up needs to be removed before you have finished the drawing, mark its position on the table-top with tape or chalk. You can then return it to exactly the right spot and at the correct angle.

LEFT Where the edge of one surface or object passes behind another, break the line a little before it meets the object in front, as this will suggest that there is a space between them. If the lines defining each shape are drawn right up to each other, this will flatten the whole image.

OPPOSITE The drawing was completed by continuing to describe the surfaces facing away from the light using a 6B pencil, and going over some of the areas previously worked with a lighter pencil. Even in the darkest areas some of the white paper has been allowed to shine through, giving the finished drawing sparkle and luminosity.

ABOVE There need not be a continuous line around every shape or surface. It is more convincing to let edges come and go, losing the outline where there is a highlight, and putting it in more heavily in shadow areas or where you want to separate an object from what is behind it.

LEFT Let the hatching lines follow the direction of the surface being described, changing direction with any changes of plane. These changes of direction also make the image more lively and interesting to look at.

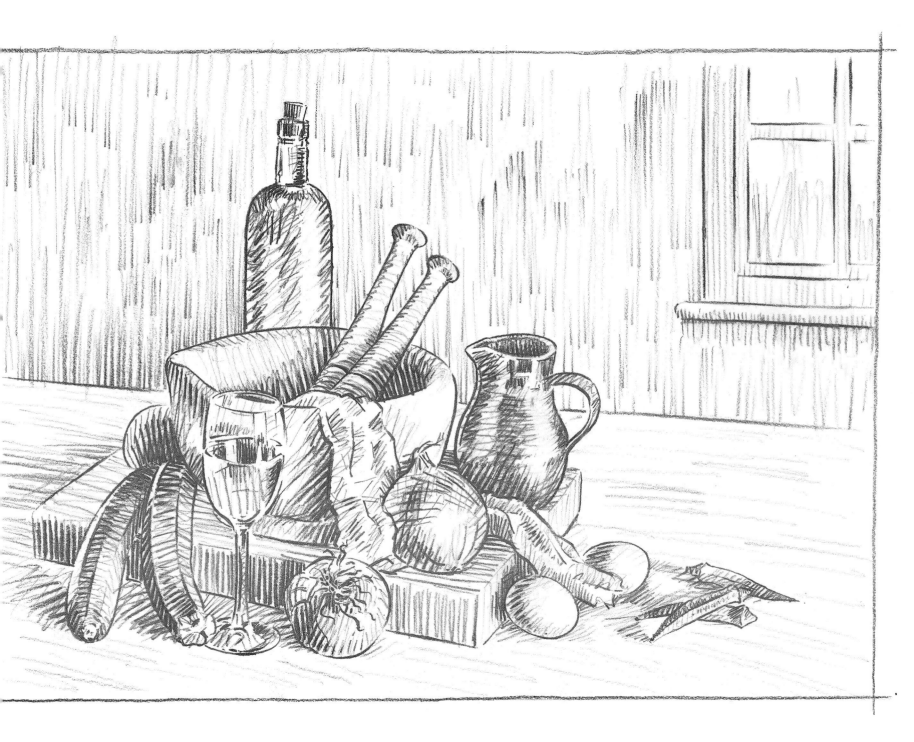

Landscape

Atmospheric Colour and Use of Pastel

One of the most enjoyable of all the approaches to landscape is to try to capture the atmosphere of a place through your choice of colours. Season, weather and light conditions combine to create distinctive moods that can be captured through the interplay between bright and dull, or warm and cool colours: for example, cold blue-greys and violets in winter, or fresh, sharp greens in early summer, and reds, golds and ochres in autumn.

Pastels are an ideal medium for creating atmosphere through colour and expressive marks. You don't need to reproduce the colours you see. Rather, analyse the mood of the scene, and select a small number of colours that reflect it. Choose five or six colours and a medium-toned paper that doesn't contrast strongly with the colours or tones being used.

The scene chosen for this project is a cold winter night with frost on the ground and moonlight catching the tops of the clouds. The cold atmosphere is created with Prussian blue, its coldness being emphasized by the mid-toned blue paper. A very light tint of Prussian blue has been used to describe the frosty ground. Black provides the contrast in tone that creates the strong light catching the tops of the

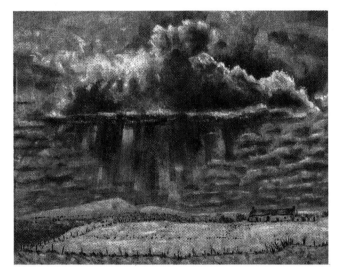

clouds. A couple of quite different palettes have also been suggested to give you other ideas.

It is worth noticing that, in each case, all of the colours but one are harmonious with the paper. The slightly jarring colour is brighter than the rest. Use this colour sparingly in the drawing to provide touches of contrast and focus.

The power of colour to create or negate space means that it can be used to evoke big spaces and distant horizons, or a heavy, brooding, close atmosphere. The use here of the same strong tones and colours in the sky and the land at the horizon as well as in the nearer parts, flattens the image, increasing the brooding character of the sky. The horizon has been placed low, so the composition comprises mainly sky, which heightens the drama of the scene.

You could use this project as the basis for a series of studies of a place that you have easy access to, recording it at different times of the day and year. Aim to record the specific sense of time and the weather conditions through the colours you use. You could also experiment with more strongly coloured papers, choosing ones that contrast with your selected colours.

Atmospheric palettes

The palette for the project runs from a very light cobalt blue, which reads as white on this paper, to a deep Prussian blue, with black for the darkest tone. A deep blue-violet, in reality a violet grey, provides touches of warmth.

Blues Paper – mid grey-blue. Top row: blue-grey, deep blue-violet, deep Prussian blue. Middle row: light cobalt blue, very light cobalt blue, dark cobalt blue. Bottom row: black.

RIGHT These two palettes create quite different moods, one the colours of a misty, early-summer morning, the other of hot, parched prairie colours. The colour of the background papers is neutral in terms of the light/dark and warm/cool relationship.

Greens Paper – light grey-green. Top row: permanent green deep, permanent green light, chrome green deep. Bottom row: yellow ochre, deep yellow.

Reds Paper – buff. Top row: orange, carmine red, madder lake deep. Bottom row: deep orange, very light oxide red.

Horizon level

The placement of the horizon also has a strong effect on the atmosphere evoked by a drawing.

BELOW LEFT If the horizon is very low, with little of the land itself included in the drawing, the horizon seems to be far away, and all the emphasis is thrown on to the sky, evoking a strong feeling of space and freedom.

BELOW If the horizon is placed very high in the picture, it appears to be quite close and the resulting impression is closed in and claustrophobic.

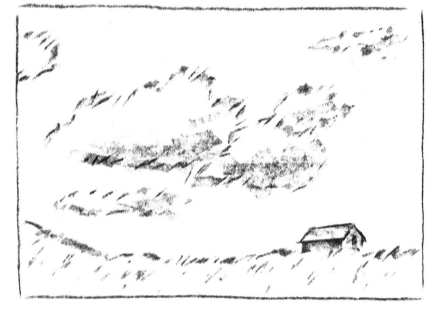

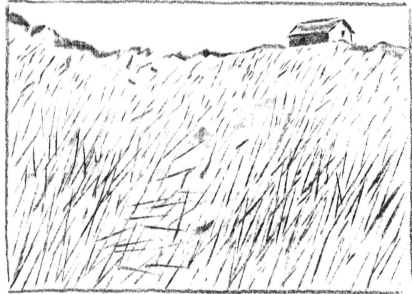

**Mood through colour
and light**

RIGHT Pale blues describe
the land.

LEFT The clouds are built up
with strong contrasts
between the lightest and
darkest tones, which places
the main focus of interest
there, and the dark,
brooding colours create
solidity and volume.

BELOW Dark blue is laid
over light, and both are
dragged with a finger to
convey reflected light in
the sky.

BELOW Touches of blue-
violet, which appears warm
against the cold pure blues,
pulls some of the sky
forwards.

OPPOSITE The colours that have been used are not the
actual colours in the scene, but they convey a sense of
intense cold and a dark, heavy sky animated by intense
patches of light. All the colours have been used throughout
the drawing. No colour distinction has been made between
sky and land, although the tonal balance varies, the land
being light with touches of dark and the sky mainly mid and
dark tones with touches of light. The paper shows through
both light and dark areas, providing a lighter tone against
the dark colours, and a darker tone against the light areas.

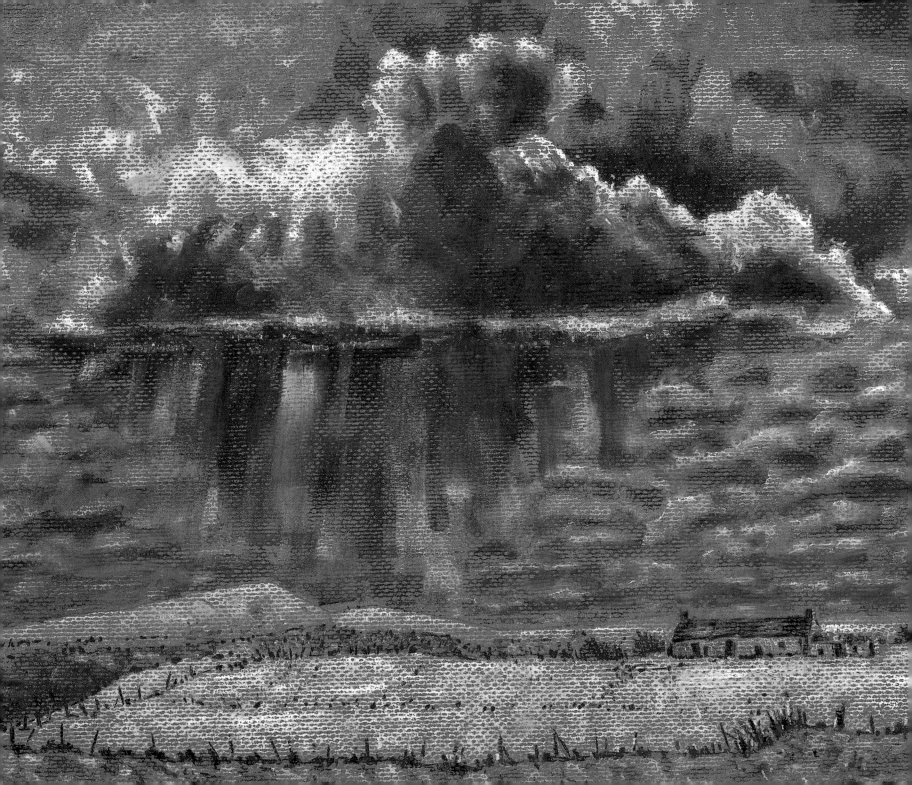

Through a Window

Drawing With Tone

Views through windows, which are almost like pictures within pictures, offer excellent subjects and have great potential for exploring aspects of composition and space – inside and out. There is often a strong contrast between interior and exterior because bright light outside intensifies the darkness within. In other words, to convey a sense of strong light outside, you need to deepen the tones of the interior.

Plan the tonal organization of the drawing before you begin. The strongest light/dark contrast will attract the eye, so decide where you want the centre of interest to fall and place the lightest light against the darkest dark there. Tones in the rest of the drawing should fall between the two. With this type of subject, this contrast will occur where light from the window meets the interior. The stronger the contrast, the more powerful the light effect will be, so use the full range of lights and darks.

To start with, take a few objects that are different shapes and place them on a table in front of a window. The table-top in the demonstration is highly reflective, which introduces reflections as well as shadows into the composition. Arrange the objects so that they create interesting negative shapes (pages 34–5), and position one or two

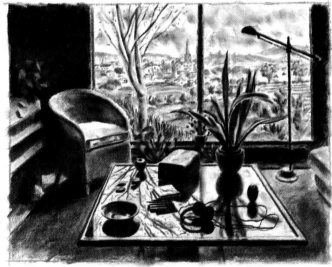

objects so that you see them framed in the window.

Beyond lightly plotting key features on the paper, don't draw the composition first, but work from the beginning in blocks of tone. Then you can gradually build up the drawing, concentrating on assessing the correct tones. Remember to judge the individual tones in your subject against others, both near by and in other parts of the scene (pages 46–7). Don't attempt to put too much detail into this type of drawing. The aim is to create an impression of bright light shining in from outside, creating strong contrasts between light and dark in the area just inside the window.

To make the landscape seen through the window appear much further away than objects inside the window, make the tones lighter and less contrasting in the distance (pages 46–7), and reduce the level of detail and texture.

Use charcoal and a lightly textured paper that holds the charcoal, and use increased pressure and layering to develop depth of tone in the shadow areas. You can use an eraser to take out highlights in areas that have been overworked, as well as to blend tones and create marks and texture by working into areas of charcoal.

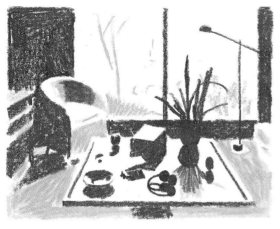

Planning the composition

A compositional sketch is done in three tones in order to plan where the strongest contrasts will occur. The centre of interest is the table-top with the objects reflected in it, so the main light/dark contrasts occur here.

3 Having established the tonal range from light to dark, the mid and lighter tones are introduced. The area through the window is pitched in a narrow range of lighter tones than the interior so that it recedes into the distance.

4 Areas of tone have been blended to give a softer, less textural effect. This is particularly obvious in the objects on the table, the chair to the left and the carpet.

Building up the drawing

1 The position of the main objects in the composition is established with light pencil lines.

2 The darkest areas, which all occur within the room, are blocked in as general shapes.

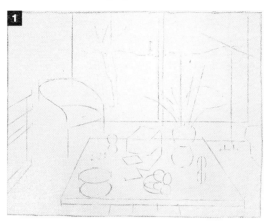

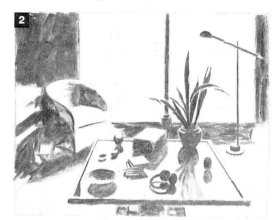

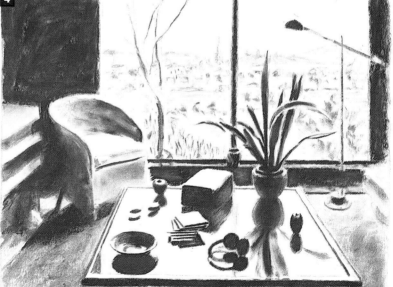

Helpful Tips
● Think of the eraser as an additional way of making marks or adjusting areas of tone. Apply the eraser in the same way as the charcoal, making the same kind of movements, and you can draw with it, keeping the marks in the same style as the rest of the drawing.

RIGHT The plant knits together the foreground and the background.

BELOW No shape on the table, positive or negative, is seen in isolation. They cut into or overlap each other, or are linked by shadows and reflections.

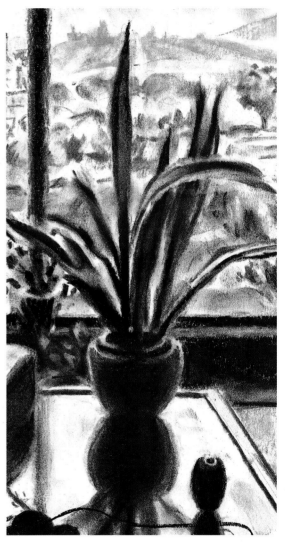

Creating a unified image

ABOVE The lamp silhouetted against the view outside helps to create the sense of distance.

RIGHT The background is sketched in light tones that contrast not only with the interior, but also with the tree outside the window, creating an impression of deep space between the plane of the window and the far distance.

OPPOSITE The reflection of the tree outside has been added on the table. Strong contrasts within the room are used to suggest strong light outside, and the whole image is built up through the juxtaposition of blocks of tone.

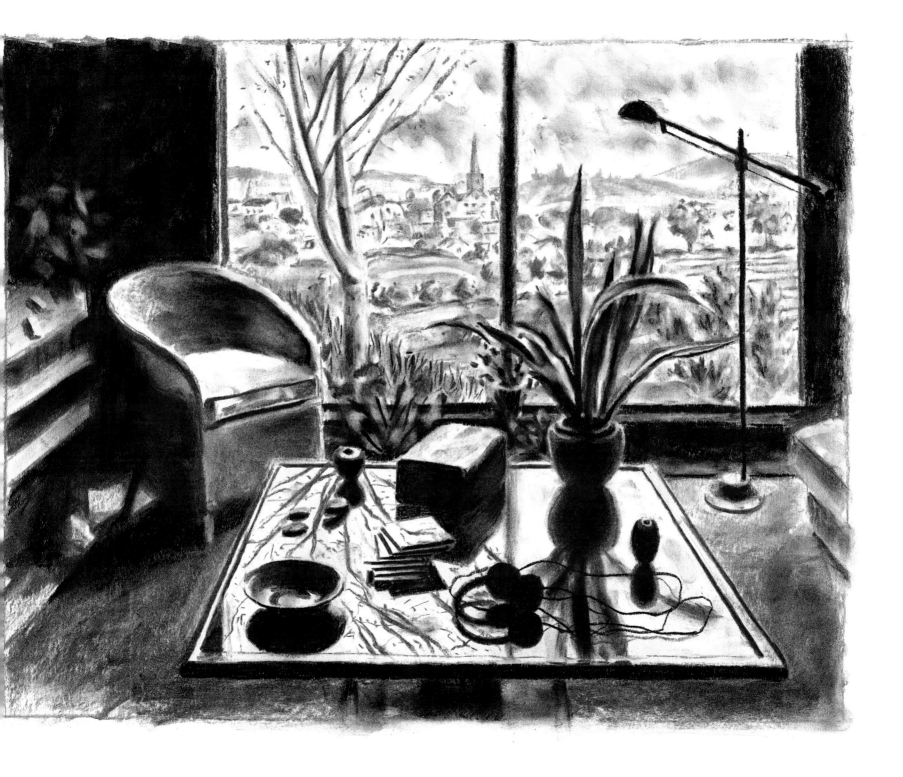

Landscape

Space and Texture Through Markmaking

You don't have to set out to make a precise drawing of the subject. Instead, you can reduce it to its component parts of form, patterns and textures and develop them until they actually describe the subject: that is, you are interpreting the subject through the medium. Instead of drawing outlines or creating blocks of tone, develop different types of pencil marks and set them against each other in order to convey what, in this instance, is quite a complex subject – different types of foliage, buildings, a pathway, distant hills and sky. The aim is to explore the suggestiveness of lines used as marks to record information on shape, texture, light and shade, and spatial relationships. You can work with a range of pencils from 2B to very soft. A smooth or medium paper is best for the exercise.

Landscape is particularly well suited to this approach because of the range of different forms, textures and patterns that are often evident within the subject. If possible, choose a landscape that has a mixture of different types of crops and foliage that create distinct lines and patterns in order to give yourself plenty of material to work with. If possible, include some buildings to provide a complete contrast in texture, too.

This is the way to begin developing a very personal and expressive approach to drawing, because there are no rules or limits on the marks you can make. The only criterion is the appropriateness of the marks to the subject in hand.

Work freely, letting the pencil follow patterns and directions, the direction of lines and marks describing planes and surfaces – vertical marks for vertical planes, horizontal marks for flat planes, scribbles for tangles of foliage. The pencil can be smudged with a finger in places for touches of solidity and to break up larger areas or marks.

In order to reduce features to their essential characteristics, decide on their overriding quality and convey just that – spiky bushes, grasses bending in the breeze, or lines of crops. Apply the rules of perspective, linear and aerial (pages 36–7 and 44–5), and reduce the weight and size of the marks in the distance in relation to those in the foreground to suggest recession and keep objects in the foreground and distance in the correct scale.

To begin with, pencil is a good medium for this approach, but once your confidence has grown, you could try pen and ink, or incorporate colour as well by using colour pencils or felt-tip pens.

Helpful Tips
● If you have trouble choosing which part of a view to draw, use a viewfinder – which can be made by cutting a rectangle out of a piece of card – to isolate individual areas. Move it around until you have a good composition.

BELOW A landscape has been reduced to bands of very simple marks that nevertheless define the texture of the land, the forms of the hills, a stormy sky and a deep sense of space.

Simplification
Try sketching individual features when you are out and about with your sketchbook, looking for ways to reduce them to their essential characteristics, and experimenting with different ways of conveying texture, pattern and a sense of solidity.

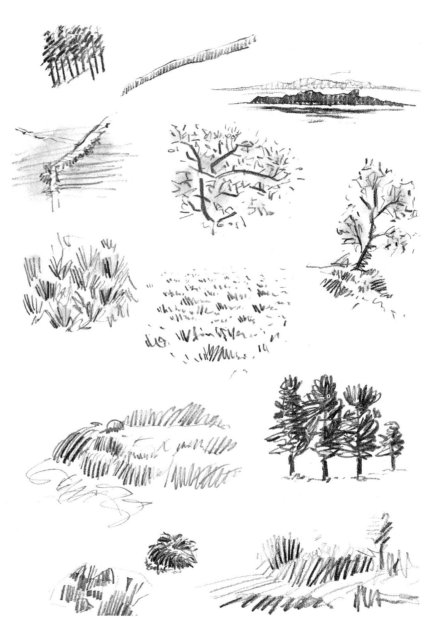

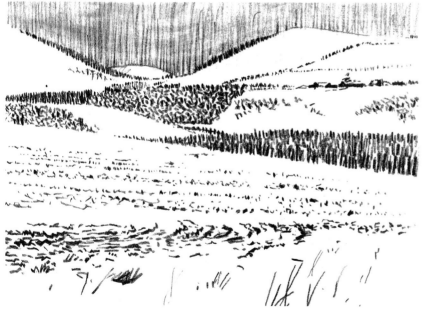

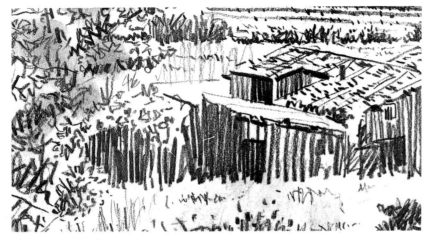

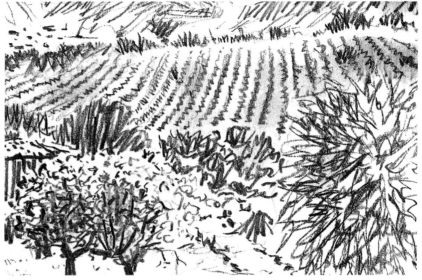

Contrast and variety of mark

ABOVE Strong light and dark contrasts are used to describe the huts and to focus the viewer's attention in that area.

ABOVE RIGHT Different types of foliage and crops are described by setting one type of scribble against another.

RIGHT The simplicity of the marks increases and the scale decreases as the scene recedes into the distance.

FAR RIGHT Three-dimensional modelling is suggested by varying the weight and density of the marks from one side of the bush to the other.

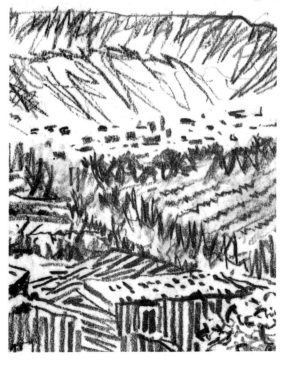

Helpful Tips
● Medium-soft pencils such as 2B and 4B are easier to use for this kind of work than very soft 6Bs to 9Bs, whose leads will wear down and thicken very quickly and need sharpening regularly. However, it is important to introduce soft pencil marks as they produce broad, dark marks to contrast with the lighter ones.

OPPOSITE The different elements in the composition are seen as forms and shapes that are plotted by setting one type of mark against another. The character of the marks embodies the surface and textural qualities of each.

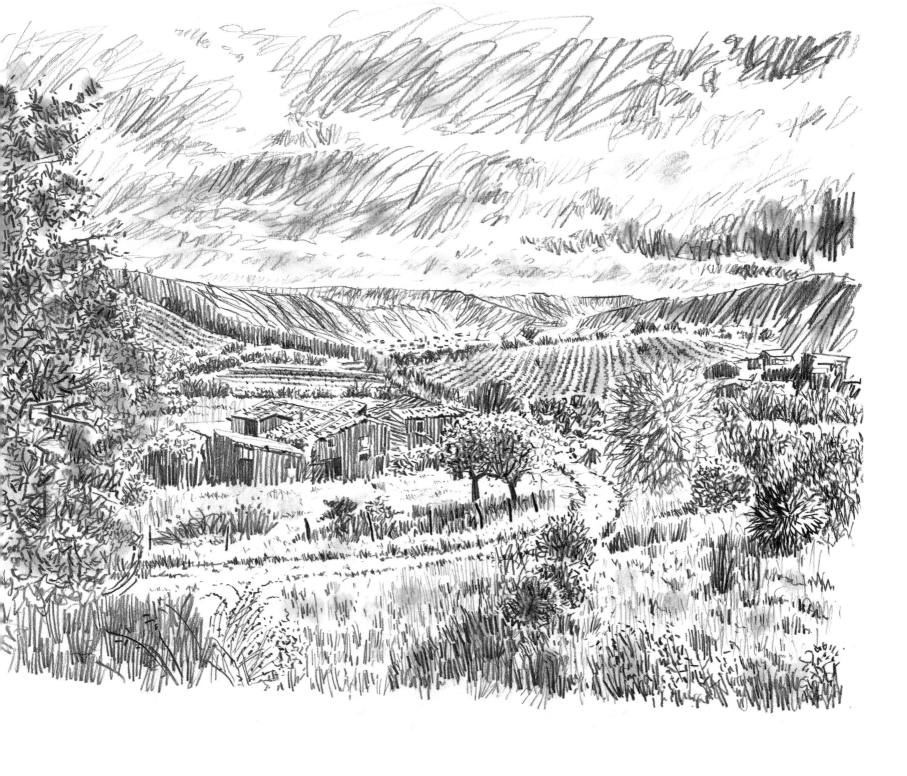

Flowering Cactus

Observed Color and Optical Mixing

Flowers and plants of all types provide an excellent opportunity to study and celebrate the wonderful colors that occur in nature. And, in one form or another, they can provide colorful subjects all year around.

Confronted with a vibrant subject that includes variations on the same colors – a range of different greens, pinks, and so on – it can be difficult to decide exactly what kind of green, or pink, each is. A good way to deal with this is to analyze colors in terms of tone and color temperature. Ask yourself whether a color is light or dark compared to the tones around it, and whether it is warm or cool – i.e., in the case of a pink, does it tend toward orange or violet? Then look for places where reflected colors are being picked up, either from another part of the subject or from the surroundings.

Color pencils have been chosen for the project because they combine ease of use and direct application of color with the potential to create a wide range of colors and tones through hatching and cross-hatching (pages 48–9). Have a good selection of the colors present in your subject, and work on a smooth or slightly textured paper to get the best results.

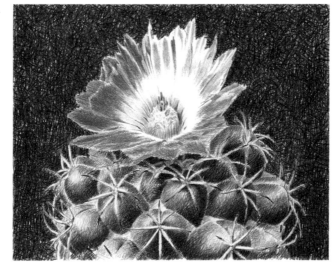

Choose a plant with vibrant or unusual colors and strong, clearly defined shapes within the flowers and leaves, and set it in front of a simple background. Begin by making an outline drawing with a light gray pencil to establish the main shapes. Then block in the main areas of color, leaving highlights as white paper, for the time being. Next, work back into the shapes to establish the volumes, using darker tones of the same colors. The final stage is to introduce reflected colors from the surroundings in the areas where you see them. Develop the background at the same rate as the main subject so you can judge one against the other.

In order that the colors you use will mix optically on the paper (pages 54–7), develop the drawing by hatching lines using the points of the pencils, rather than making areas of continuous shading. In the demonstration, the hatching varies in direction all over the drawing rather than following the forms. This allows the color to work to full effect in modeling the volumes of the plant. Keep the hatching quite loose, as in the still life project (pages 82–5), and try to treat the subject as a pattern of different-colored shapes with light, dark, and reflected-color modulations worked into them.

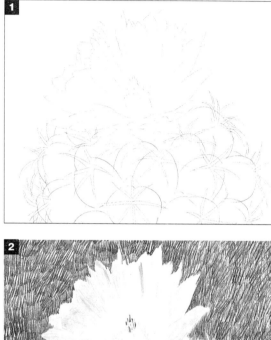

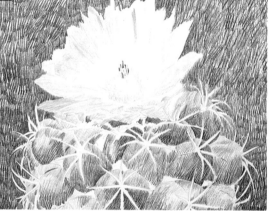

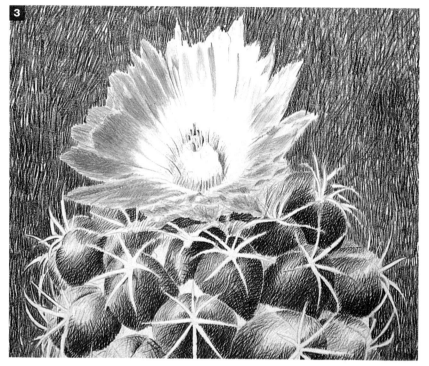

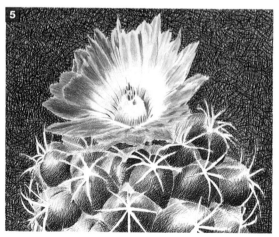

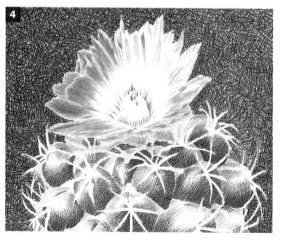

3 The volumes of different parts of the plant are developed, mainly by strengthening the colors already present, although blue is added into the greens on the leaf nodules to make them appear rounded. The background is worked up at the same rate as the plant.

4 Reflected colors are introduced into the plant and the background, for instance on the leaves facing the flower, which have touches of red worked into them. The colors are intensified in the center of the flower to define it more clearly.

5 Reflected colors from the plant are worked into the background, and warm colors are added into the spikes and some of the leaves.

Building up the image

1 The main shapes of the cactus are drawn in with a soft gray pencil that will disappear under the drawing.

2 The general colors in each area are established, and the colors are kept almost flat. The flower is hatched in with a red pencil, leaving the lightest areas as white paper, and the colors in the center are just hinted at. The leaves are hatched in with green, with slight indications of shadow, and the background is put in with indigo blue.

Form and space through color

BELOW Red is worked into the green of the leaves where they are reflecting color from the flower.

Helpful Tips
The sharpness of the point of a color pencil will affect the character of the lines and marks that you can make. For sharp, precise lines, bring the pencil to a sharp point and keep re-sharpening it as you work. This will give a more consistent line. If you want a softer, more broken line, use a thicker, blunter, rounded point.

OPPOSITE A richly woven web of multidirectional hatching across the whole drawing produces an image of great depth and luminosity, in which light and dark and warm and cool colors model the forms of the plant.

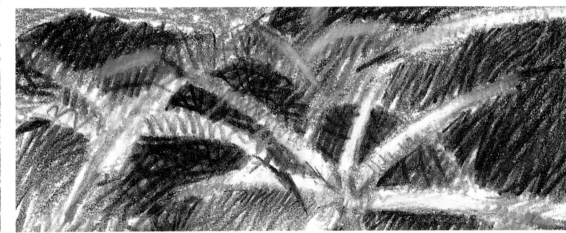

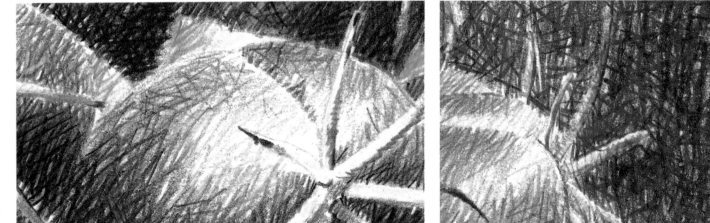

ABOVE Large areas of the paper are left white in the flower. Depth is suggested at the center through the juxtaposition of light and dark tones.

RIGHT The rounded forms of the nodules are suggested with a cool, dark blue-green in the shadow areas and pale green in the light areas.

FAR RIGHT Plant and background are differentiated through nothing more than a change in color and tone.

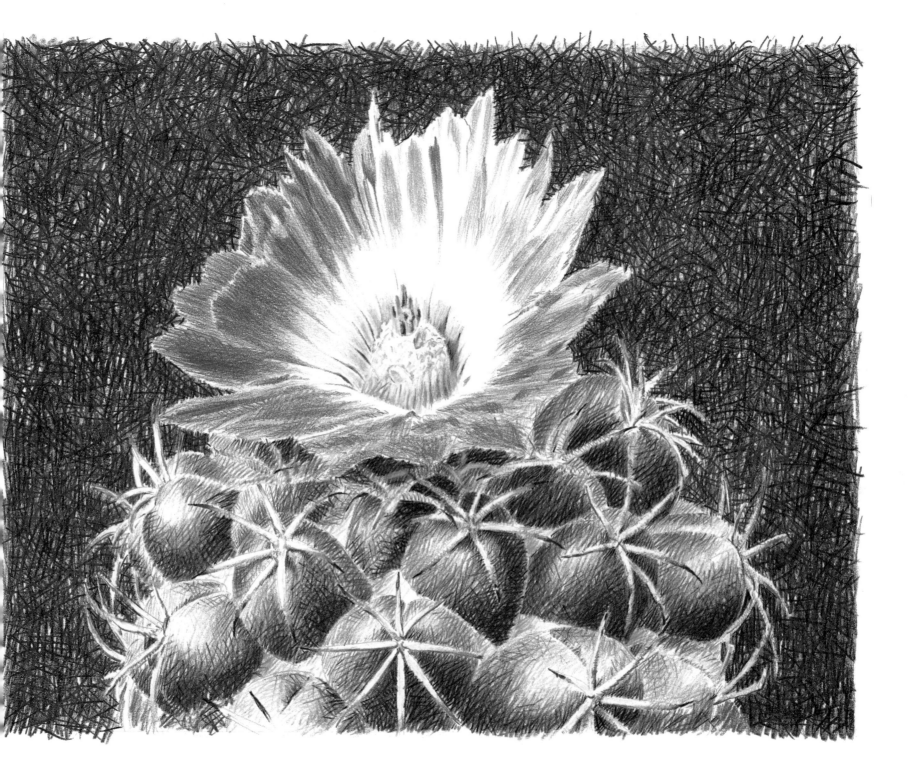

Figures – Heads

Drawing the Head by Modeling Forms

The best approach to drawing the human head, if you haven't tackled this subject before, is to ignore the fact that it is a head and concentrate instead on analyzing the structure by the way it is revealed through light and dark tones.

The materials for this project are gray conté chalks in five tones, from white to very dark, and a mid-toned, textured gray paper. Because of its textured surface, the paper shows through the chalks across the drawing, and in places has been allowed to stand as a mid-toned gray. The limited range of tones allows you to build up the image as simple blocks of tone, but they can also be laid over the top of each other and blended to provide smooth transitions from light to dark where necessary.

The head is a series of planes, some of which, like the nose, protrude, and some of which, like the eye sockets, recede. The forehead, cheeks and chin, on the other hand, are gently curving surfaces. The planes and surfaces are revealed by light falling on the head, so note the direction of the light and the way that surfaces facing it are lit, and those facing away are in shadow. Gradually build up the darker tones to the point where the form takes on shape and solidity. There

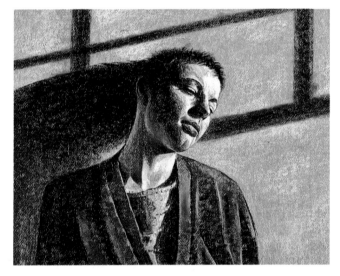

is no need to put in details such as eyelashes or individual hairs on the eyebrows. The overall shape and proportions of the head, the shape of the eyes – best defined by the shapes of the shadows in the eye sockets – the shape of the nose, and the line of the mouth, are far more telling and convincing than the inclusion of fine details.

You do not need to ask someone to pose specially for you. It is often better to draw family or friends when they are concentrating on some static activity – such as reading or watching television – or when sleeping. And remember that you also always have a model for this subject in yourself.

When you feel confident about tackling heads, you could try a portrait, the difference being that you set out to capture a likeness. Look at the main features which give the face its idiosyncrasies, and develop your drawing from there. Even with a portrait, however, begin by analyzing the basic proportions of the head. Then slightly exaggerate the most characteristic features, usually the eyes and mouth. You could also try tackling this subject in color. Work with a small range of colors to start with, and continue to use light and dark tones to model the head.

The proportions of the head

Knowledge of a few basic dimensions of the head, and the way they are affected by the angle at which it is held, will provide a sound basis for all drawings of heads, including portraits.

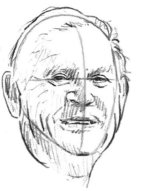

RIGHT AND BELOW Both the proportions and textures of the head vary from one age to another – a child has smooth skin with little variation in tone, compared to the older face, in which textures and lines suggest character.

The head is a three-dimensional form. The eye line, for example, falls on an ellipse, not on a straight line.

The basic volume of the head remains the same, regardless of the shape of the hair.

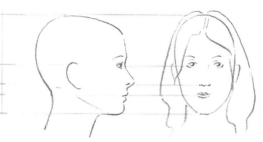

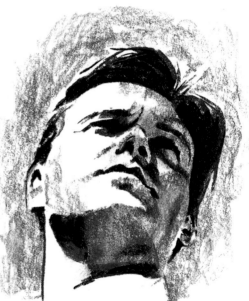

ABOVE When you are on the same eye level as your subject, the eye line is half way between the top of the head and the bottom of the chin. A common mistake is to make the top half of the head too short.

RIGHT Having established these proportions, assess where the hairline comes between crown and eyes, and where the tip of the nose and the line of the mouth fall between the eye socket and chin. Then judge or measure the width of the head against its length. Other alignments to note are the tops of the ears in relation to the eyes, and the bottom of the ears to the tip of the nose or mouth.

The head is tilted back, changing the proportions – the nearer features appearing much larger in relation to the further ones. The different planes of the features have been treated as solid blocks of tone.

Helpful Tips
● If you want to try this project in color, you should still begin by capturing light and shadows using neutral colors.

OPPOSITE The lightest lights and the darkest darks are contrasted in the face, the focal point of the drawing.

The strongly lit front of the head, and the deeply shadowed side, create a strong sense of three-dimensional form. Tones have been massed together and treated as strong interlocking shapes.

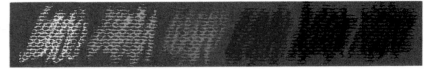

LEFT The turn of the cheek is described through an even progression from light to dark tones.

BELOW The edge of the cheek is defined by a block of darker tone next to it.

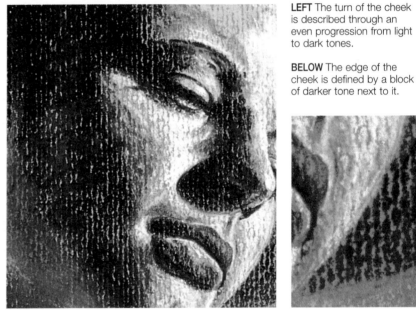

Using tone to describe volume

ABOVE The jawline and neck are defined with reflected light.

The textured paper shows through, giving luminosity to what would otherwise be very dense areas of tone.

Helpful Tips
● Fixing can dull tones and colors, especially light-toned gray chalks and lighter colors. To avoid this happening, fix the drawing before adding the highlights and any other final touches, and leave this last layer unfixed. Great care will be needed in handling and looking after drawings that have a final unfixed layer.

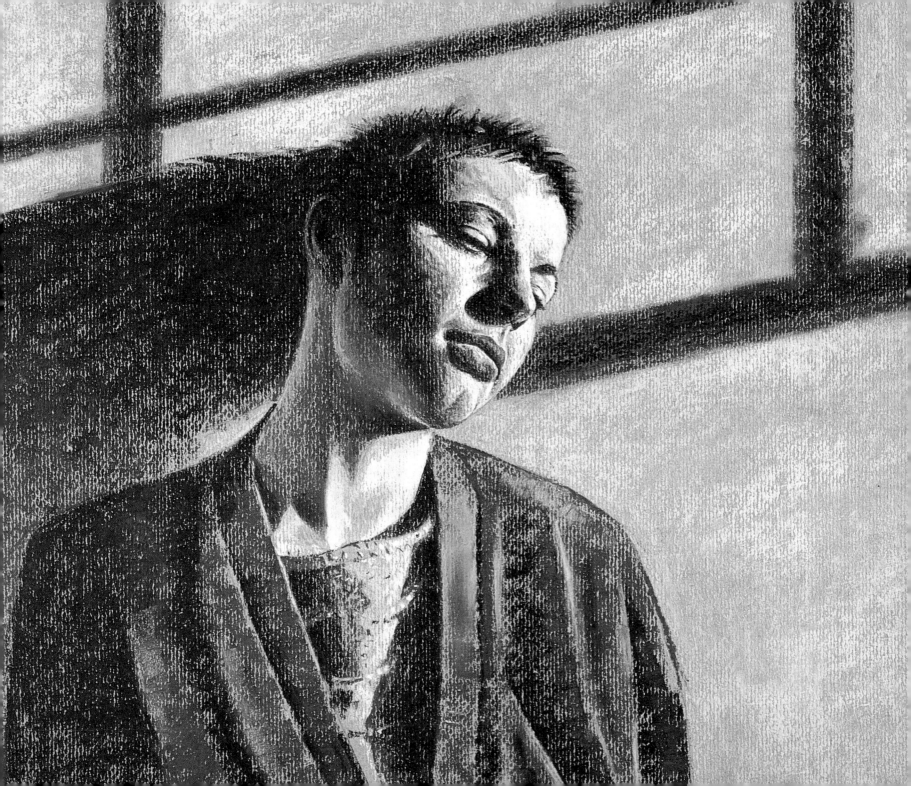

Architecture

Pen and Ink

This subject offers a good opportunity to explore the range of different effects that can be produced using pen and ink, and to find ways to describe different surfaces and textures – here, brickwork, rubble, different kinds of foliage, wispy grass, and so on – through the types of marks used. You can create many different kinds of surfaces and textural patterns with pen nibs, both through directional marks and by varying the pressure applied as lines and marks are drawn.

In this case, both a mapping pen for the finer lines and a larger drawing dip pen for the heavier lines are used. Before trying the project, warm up by doing patches of different marks like the ones shown, seeing how much variety in character, weight, and direction you can get into them – straight, curved, scribbly, curling and circular, parallel and multi-directional, closely hatched, and free and airy.

In this type of drawing, try to use as many different types of marks as possible, to provide interest and contrast across the surface. Here, straight marks have been used for walls, more irregular ones for tumbled-down brickwork. Dense, scribbly marks describe the foliage, and lighter ones the grass in the foreground. The path and hedge

leading away on the right are produced with small, lighter marks, so they don't distract from the main interest. The overhanging foliage both balances the building within the composition, and provides a good foil for the regular hatching and marks used to describe the building.

Linear perspective (pages 36–7) has been employed in the drawing of the buildings, and is emphasized by the description of the brickwork, which also follows the perspective lines. Structures and surfaces are described through the character of the marks, and tone has been created by varying the weight and density of the hatching lines. As with the landscape mark-making project, choose a subject with plenty of variety in terms of both materials and textures.

If you want take this further, you could produce a drawing in pen and ink and then add a wash, varying the extent to which you dilute the ink in order to produce different tones. If you are going to do this, there is no need to develop the hatching in the dark areas into almost solid areas of tone because the wash will supply solidity, and make sure that areas don't become so solid that they lose all sense of light being reflected by the white paper.

Drawing through combining marks

BELOW Details can be as interesting to draw as whole subjects. Rather than trying to draw an accurate version of what you see, think in terms of combining different types of marks to describe shape, form, or texture.

The potential of pen and ink

RIGHT A pen can be manipulated to produce a variety of marks. A mapping nib holds less ink than the larger nib, so can not make such long lines, but has great flexibility and splays out under pressure so the width of the line can be varied considerably.

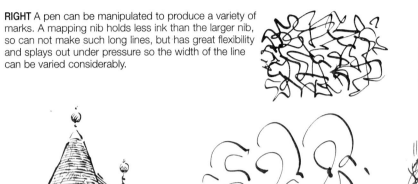

Texture, form and space
BELOW Even complex areas of changing forms, planes, and textures have been plotted purely through the juxtaposition of different types of marks.

Helpful Tips
● When crosshatching with pen and ink, you may reach a point where you think the drawing is becoming overworked. Continue through this stage, building up the tones across the drawing, and it will develop a new level of richness.

OPPOSITE Many different kinds of surfaces and textural patterns can be created with pen nibs, through directional marks and crosshatching, and by varying the pressure applied as the lines and marks are drawn.

LEFT Scribbly marks that vary in weight and width have been made with a mapping pen to describe the foliage and grass.

BELOW Even in the darkest tones, the crosshatching has not been allowed to become completely solid. Touches of white paper are allowed to show through, creating depth in the shadow areas, as well as a luminous quality.

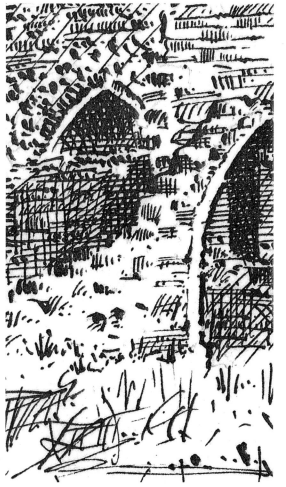

ABOVE Different planes – the front and side of the building and the roof – have been mapped out with different patterns of hatching and crosshatching, the hatching being built up quite heavily on the side in shadow.

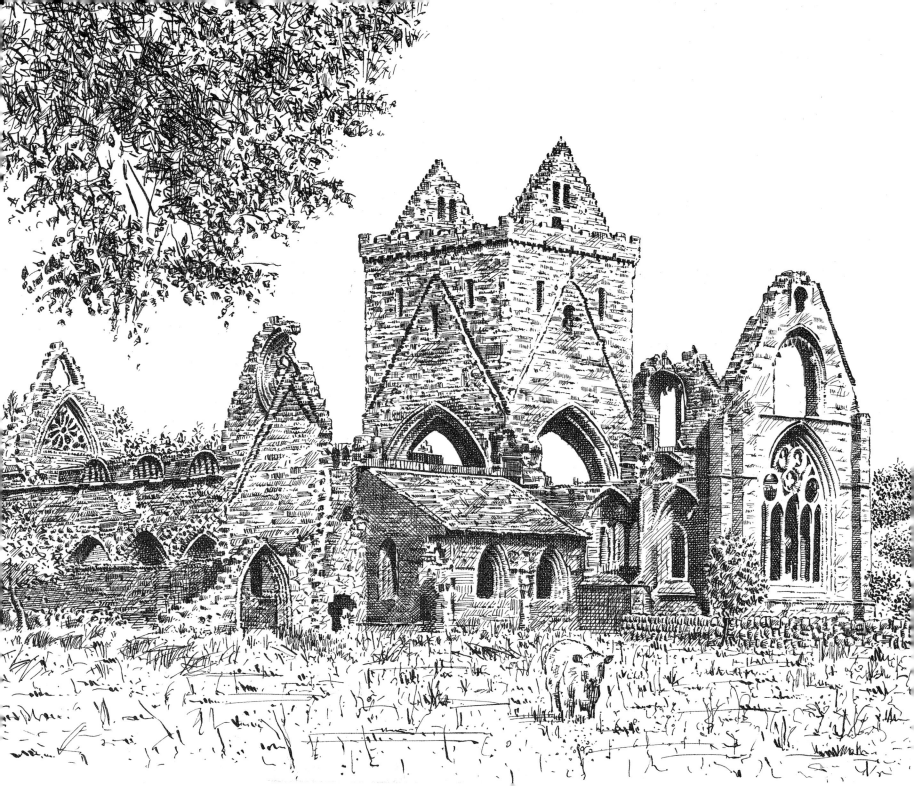

Waterside Scene

Sketching with Watercolor

Water is a fascinating and ever-popular subject, but it does present the artist with particular problems because of its qualities of reflectivity and transparency. However, there are a few pointers to look for that will help you to create a convincing image.

One of the most obvious features are the reflections on the water surface. They fall immediately below the object causing them, and extend toward the viewer. Another point to notice is that the closer the reflection is to the object being reflected, the sharper it is, and as it extends away from the object, it becomes progressively more blurred and soft-edged. In addition, the more the surface of the water is broken up by a breeze or current, the more the reflections are broken up.

Tones and colors in reflections are slightly cooler and more muted than those in the objects causing them. They are often slightly darker, too, but this is not always so. Careful assessment of the tonal values of reflections against those in the objects creating them is always needed.

When elements are set back from the water's edge, you only see the upper part reflected. The amount you can see is directly related to the object's distance from the water's edge, and, again, this will require careful observation.

Reflections shouldn't be confused with shadows. Reflections are a mirror image of the surroundings, whereas shadows are cast by objects that block the light. Your best approach is to try to see the water surface as a pattern, or mosaic of tones and colors, and to concentrate on recording this pattern.

A watercolor sketchpad, a small selection of colors, a rag or sponge, and a water container are all you need, plus two or three brushes – one large enough to cover largish areas in the drawing, the other small enough to allow you to flick in details. Mix colors by overlaying one transparent color with another, rather than premixing them on the palette (pages 54–7).

Draw in the main shapes in pencil; then work directly with a brush. There are two main approaches: you can block in individual areas of color from the start, or you can put overall light-toned washes over different areas, and, when they are dry, apply additional washes over the top to create darker tones. If paint is applied next to an area that is still wet, the two colors will bleed into each other. To prevent this, let an area of color dry before laying another next to it.

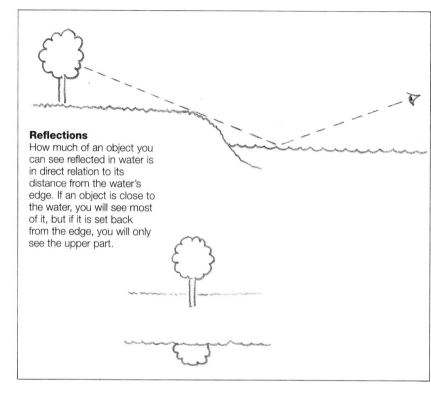

Reflections

How much of an object you can see reflected in water is in direct relation to its distance from the water's edge. If an object is close to the water, you will see most of it, but if it is set back from the edge, you will only see the upper part.

Using watercolor

ABOVE When applied to dry paper, watercolor remains where it is put and dries hard-edged. When it is applied to wet paper, it spreads across the paper and dries with a soft edge. Because the color spreads on wet paper, it is less intense than when applied to dry paper.

Finding a pattern

LEFT AND RIGHT The best way to capture reflections and shadows in water is by observing the water's surface as a pattern of shapes and colors.

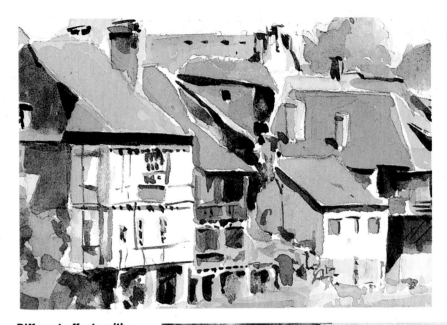

LEFT Color is used wet-into-wet in the water area to get the softness required in the reflections. The reflections are slightly darker and duller in color than the objects casting them.

Helpful Tips
If the colors look pale and washed out, it could be because you mixed too much water with the paint. Don't make the washes too dilute, and remember that watercolors dry to a lighter tone.

OPPOSITE The tranquility of this river scene is captured through the stillness of the water surface, with gentle ripples breaking up the reflections.

Different effects with watercolor

ABOVE The buildings are put in as individual blocks of color, and the details are suggested with flicks with a small brush.

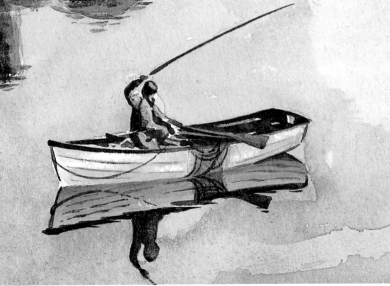

RIGHT The reflection of the boat, which is sitting on the water, is sharp, but the reflection of the rod becomes gradually more broken up toward the tip.

ABOVE Shadows are painted in a darker tone of the water's color to distinguish them from reflections.

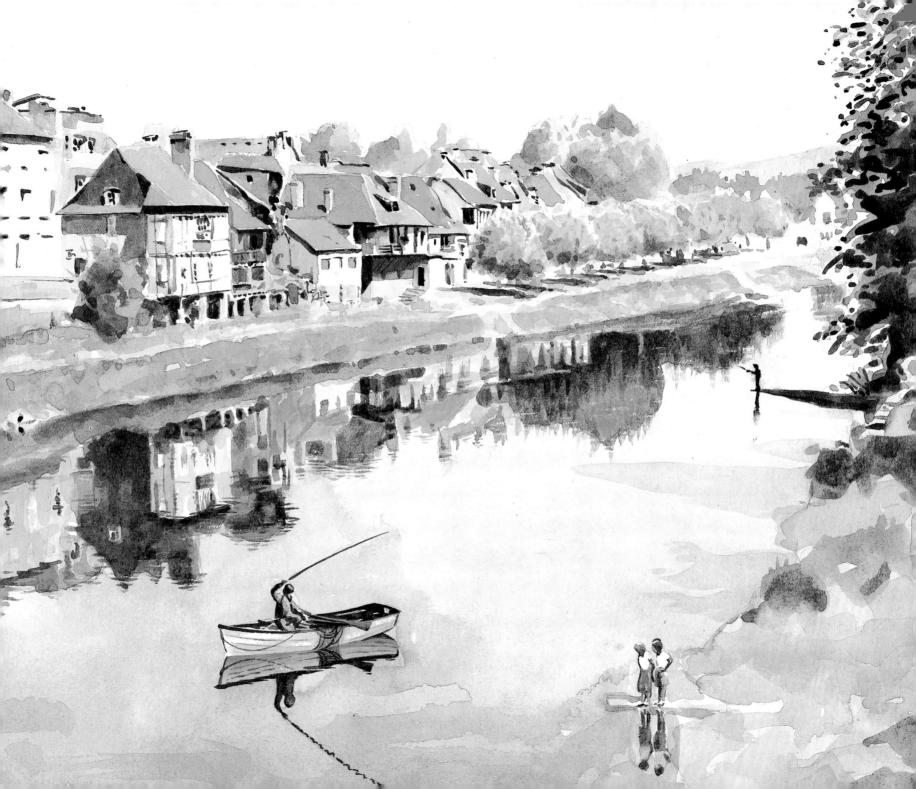

Busy Street Scene

Capturing Light and Movement

Pen and ink with watercolor washes have been chosen for this project, because the combination of the two provides the potential for capturing the mood of a busy scene and the interplay of bright sunshine and heavy shadow.

You will need pencils, pen and permanent ink, smooth or medium stretched paper or a watercolor block, a small selection of watercolors, and brushes. Do not work too small; mix up plenty of each wash so you won't need to mix up more of any color, and use large brushes to apply the washes.

The strategy for drawing a busy, changing scene is described on pages 66–7. The general approach is to establish the eye level and buildings, and then place people where you observe interesting groups. As a preliminary exercise, watch what happens when figures walk from shadow into light, and the effect this has on the colors they are wearing.

Choose a position where you can stand or sit in a quiet corner or doorway. Choose a bright day, and look for interesting patterns of light and shadow on the buildings and across the street. The strong light from one side, in the location chosen here, created such a pattern, and it provides a central feature in the composition.

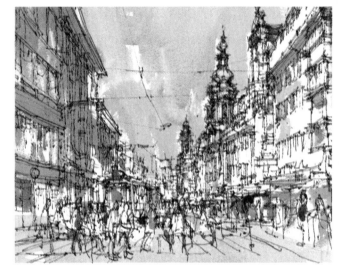

First draw the scene – you can use pencil or ink for the line drawing. Or, you could lightly map out the main features in the composition in pencil as a guide, and then draw with pen and ink. Put in all the main elements, and as much detail as you want to include. Draw in the people freely, and do not worry about treating them as individuals – in busy places we seldom see people in isolation. Try to capture the overall shapes of clusters and lines. Work as quickly as you can, and keep the whole drawing as suggestive as possible.

The next stage is to add the washes. Work with no more than three or four colors, and mix them to produce a range of warm and cool grays, diluting them for lighter tones. Don't try to fill in areas of the line drawing. Instead, think in terms of mapping broad areas of light and shadow as you see them in the scene, independent of the drawing. Leave the paper white for the lightest areas of all.

The light will change, and areas of light and shadow will move while you are working. The best way to deal with this is to pick a moment when the light and shadow form an interesting pattern, and go with it regardless of subsequent changes.

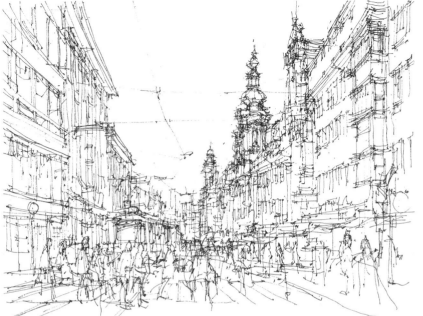

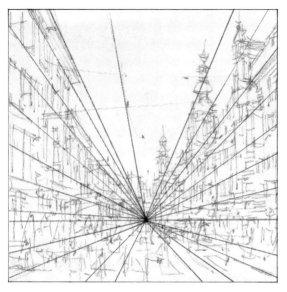

RIGHT All the perspective lines – in the buildings, the sidewalk, and the overhead cables – lead to a vanishing point that is set quite low in the drawing. The low viewpoint increases the sense of tall buildings looming above the figures.

Combining line and wash

ABOVE The line drawing is created first. Quite a lot of detail has been suggested, and it could stand as a drawing in its own right.

RIGHT The washes are applied to describe large areas of light and shadow, using a cool green-gray for the shadows on the left-hand buildings, and warm yellow, gold, and orange for the sunlit buildings on the right. Figures and other features at street level are described with blue and violet grays. The sky and distance are described with cool grays, while the street in the foreground is a warm pinky gray.

Cobalt blue

Cadmium yellow

Cadmium red light

Viridian

Palette

A limited palette of four colors has been used. They have been mixed to produce a range of warm ochres, gold and beige, and cool gray-greens, gray violets, and blues (see pages 54–7).

Atmosphere through suggestion

RIGHT The touch of bright red, the only pure color that has been used, provides a visual focal point and animates the large areas of greens and grays around it.

FAR RIGHT No attempt has been made to differentiate individual figures, but overall areas of light and shadow falling on them have been indicated.

RIGHT Heavy ornamentation on the building has been suggested, but no attempt has been made to put in any of the details.

FAR RIGHT Warm washes set off with touches of blue draw the eye upward, enhancing the effect of the low viewpoint.

OPPOSITE The looseness of the image adds to the sense of movement. No attempt has been made to match the washes to the outlines in the line drawing. They have been treated as an abstract pattern of warm and cool colors and light and dark tones, which describe light hitting one side of the street while the other side is in deep shadow.

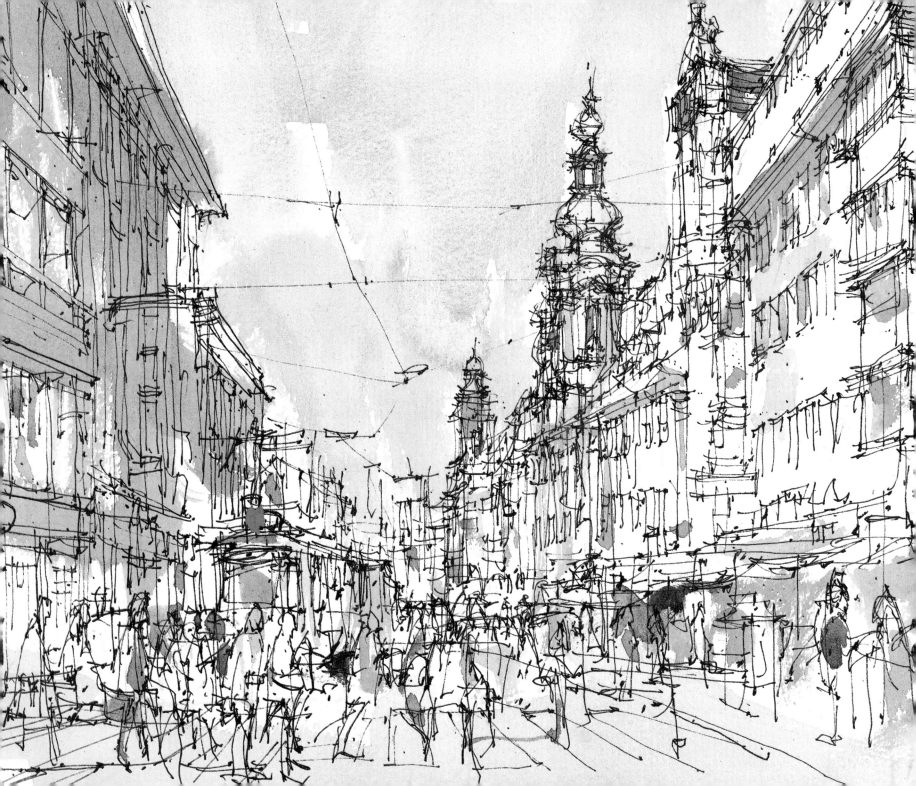

S t i l l L i f e

One Subject – Three Approaches

Many approaches can be taken to any one subject of a picture, and you should try different ways of looking at objects before deciding on your preferred view. This project looks at the ways in which a simple household object can provide material for a series of very different sketches.

Even the object chosen to illustrate this project – a cafetière coffeepot – provides many possibilities for different treatments. The chrome top is highly reflective, and the glass is reflective and transparent. These qualities of smoothness and reflectivity can give rise to interesting studies. The form of the coffeepot is cylindrical, offering a challenge in modeling it. Alternatively, it can be taken apart and arranged into a composition that can be explored for its abstract qualities, making use of the shapes of the different parts, and the shapes and patterns within shapes, such as the holes in the plunger and the wire mesh of the filter.

Decide which approach you want to take in any drawing – realistic, loose and expressive, abstract – and which aspects you want to emphasize – the surface qualities and textures, the structure, or the shapes and patterns found within it. Then choose the materials and

techniques that you think will best bring these out. Smooth, reflective surfaces can be modeled with carefully graduated tones using pencil or charcoal. Or, you can use line to make a carefully observed drawing of the structure of the object, recording the correct shapes and proportions, and the effects of perspective. For an abstract approach that concentrates on the shapes of the different parts, move in close and frame the composition so the shapes are cropped off by the edges of the drawing, and work in either tone or color.

Choose three quite different mediums for the three sketches. For this demonstration, pencil is used for a realistic approach that recreates the pattern of reflections through careful assessment of tones and smooth blending; brush and watercolor are used for a loose, expressive way of working that captures the form through the use of line; and color pencils are used for developing an abstract pattern. Other possible objects that you could use for this project are: a bicycle, a pair of shoes, the internal workings of a clock, a plant that has strong shapes and structure, or a group of plants. You could then move on to try different approaches with an outdoor subject, but keep the composition simple to start with.

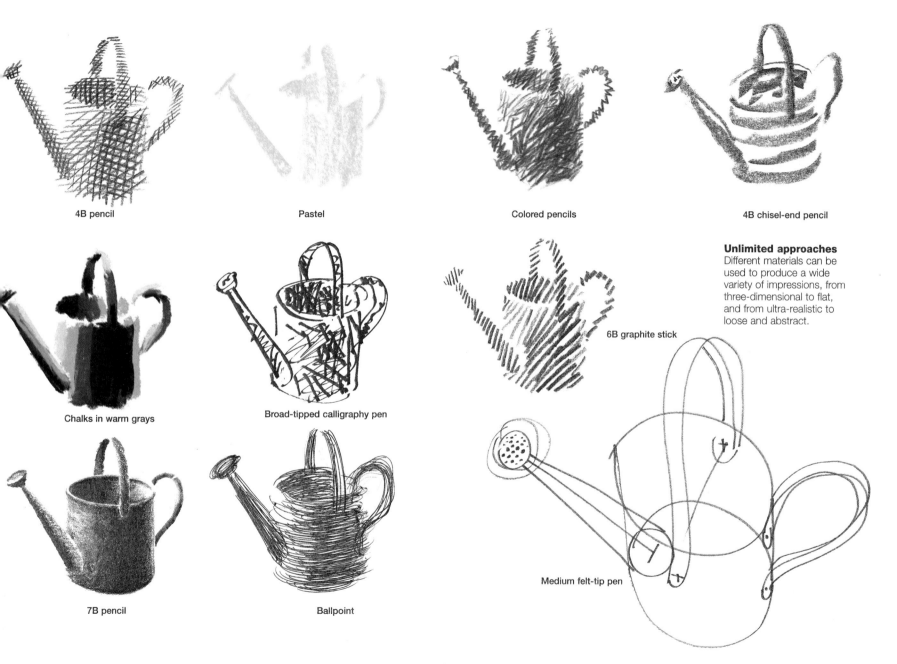

4B pencil

Pastel

Colored pencils

4B chisel-end pencil

Chalks in warm grays

Broad-tipped calligraphy pen

6B graphite stick

Unlimited approaches
Different materials can be used to produce a wide variety of impressions, from three-dimensional to flat, and from ultra-realistic to loose and abstract.

7B pencil

Ballpoint

Medium felt-tip pen

BELOW Loose tonal washes are applied to create a sense of volume and solidity.

Different materials and approaches

ABOVE The reflections in the coffeepot lid are captured with carefully controlled pencil shading.

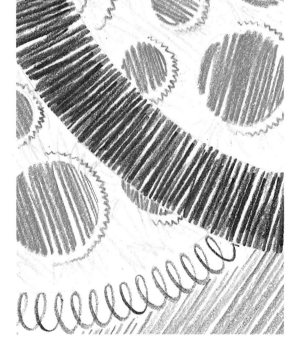

RIGHT Shapes within the different parts of the coffeepot, and the spaces between them, are treated as equally solid areas, and are developed in simple but different ways to produce an abstract pattern out of an everyday object.

ABOVE Fine details are meticulously described through tonal contrasts.

Helpful Tips
● Use the pencil point on its side to get even shading and build up tone gradually from light to dark in order to get an even gradation.

OPPOSITE Three approaches produce three very different drawings. A pencil drawing, with careful tonal blending and attention to detail, produces a degree of realism that is almost photographic, whereas a loose drawing with brush and ink, with details suggested rather than carefully defined, captures the volume and character of the pot. With the individual parts of the pot rearranged, it is possible to see the subject as a series of shapes and patterns that can be developed with different colors and marks.

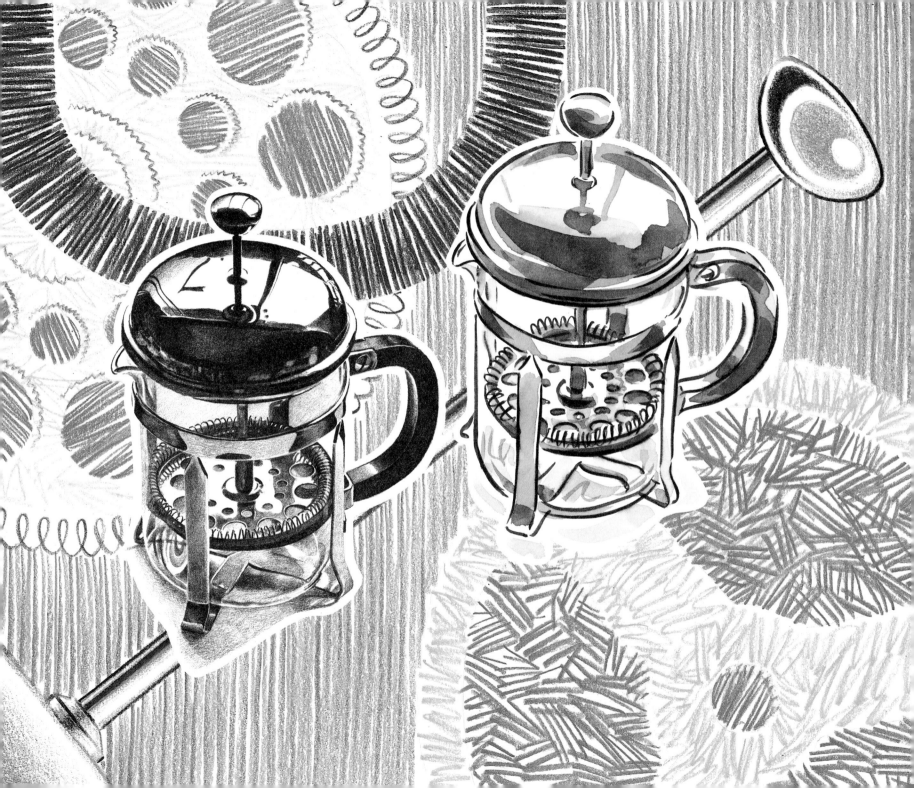

Figures in a Setting

Exploiting Color and Shape

This project explores the use of mixed media. The combination of subject and technique is more challenging than previous projects, but it is worth tackling for the excitement that mixed media can generate, and to explore the possibilities for manipulating color and shape in order to create a strong picture.

The subject has been organized into three horizontal bands. The top band comprises a very simple background. In the middle band, strong, contrasting colors – blue and orange – have been used to focus attention on the figures (pages 58–9). The bottom band provides a simple foreground broken up by the shapes of the men's feet and the pigeons. The top and bottom bands both form strong negative shapes around the central area, the whole image fusing together in a series of interlocking shapes (pages 34–5).

This subject is best developed at home from sketches done on site, but try to retain a sketchy feel by working quite quickly. Collect all the information you need for the figures and background, details, textures, and colors in a sketchbook (pages 62–3).

When tackling a group of figures, draw them as one overall shape initially, and then add the touches that differentiate one figure from

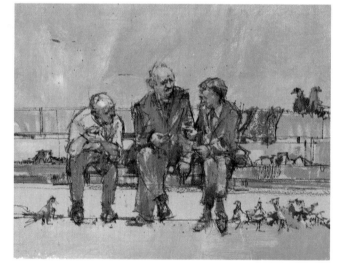

another. The overall directions within each figure – the angles of shoulders, arms, and legs – the relative positions of one part to another – where the legs fall in relation to the shoulders – and the distribution of weight, have been carefully observed (pages 32–3) to capture the specific poses of the figures. Directional lines have been followed through from one figure into the next to link them into an overall group. It is important to treat the subject and the background in the same style, continually working between the two and assessing one against the other.

The use of different media was planned, with blue pen for the drawing, acrylics providing the foundation of warm and cool colors, and oil pastels being used to add touches of bright color that reinforce areas of light and shadow and lead the eye across the drawing. A smooth watercolor paper has been used.

The paper you work on will need to be stretched (pages 72–3), and the addition of a background wash is advisable because it will help to unify the finished picture. Choose a small number of colors in each of your chosen media. Acrylics or gouache with oil pastel used over the top produce a good combination.

Building up the drawing

1 The paper is given a background watercolor wash of yellow ochre.

2 The figures are drawn in, using a blue technical drawing pen with a fine nib. Despite the sketchiness of the drawing, the figures are carefully observed.

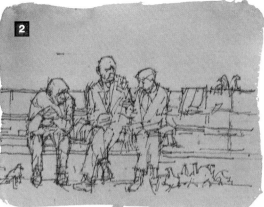

Palette
Acrylic colors

Permanent magenta

Vermilion hue

Winsor blue

Cadmium yellow

Oil pastels

Burnt sienna

Fir green

Prussian blue

Orange

Yellow ochre

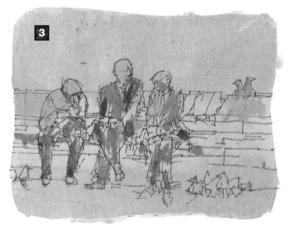

3 A pink, acrylic wash is added across the background and foreground, and strong blues and blue-greens in acrylic are used to begin to define the forms of the figures. These stronger colors establish the figures in a nearer plane than the background.

4 Touches of color are added with oil pastels. The strong colors in the figures are balanced by earth reds and dark blues on the seat. Touches of orange on the front of the bench pull it into the same plane as the nearer parts of the figures, whereas the back of the bench is duller.

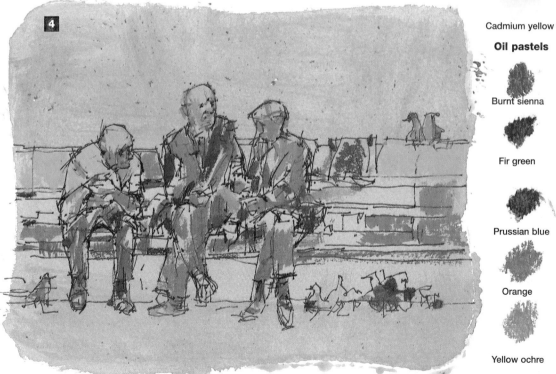

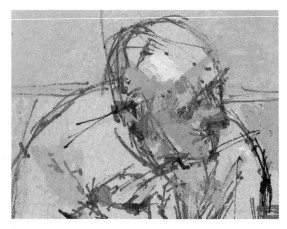

Creating a unified image

ABOVE One simple highlight has been added to emphasize the position of the figure leaning forward.

BELOW The horizontal lines of the bench are broken up by simple shapes described with bright colors. These provide interest right across the picture, although they fade out toward the edges.

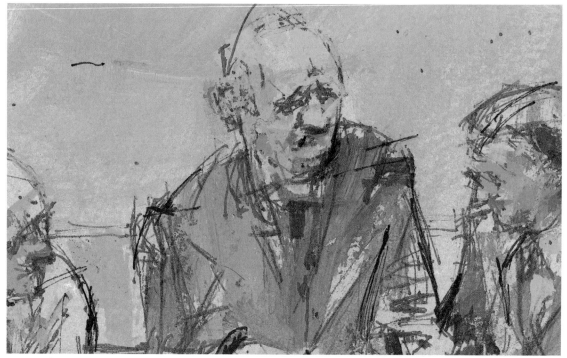

ABOVE The pigeons are treated as linked shapes, and drawn in the same style as the men's feet, but are less strongly stated. The feet and pigeons break up the horizontal line along the bottom of the bench, linking the middle and lower areas of the drawing.

ABOVE The background is allowed to extend down between the figures to form strong negative shapes.

OPPOSITE Some areas are reinforced with more linework. The original background wash has been left to show as a light tone across the middle of the drawing, which contrasts with the blues of the figures. Tonal and complementary contrasts are used to draw the viewer's eye across the drawing.

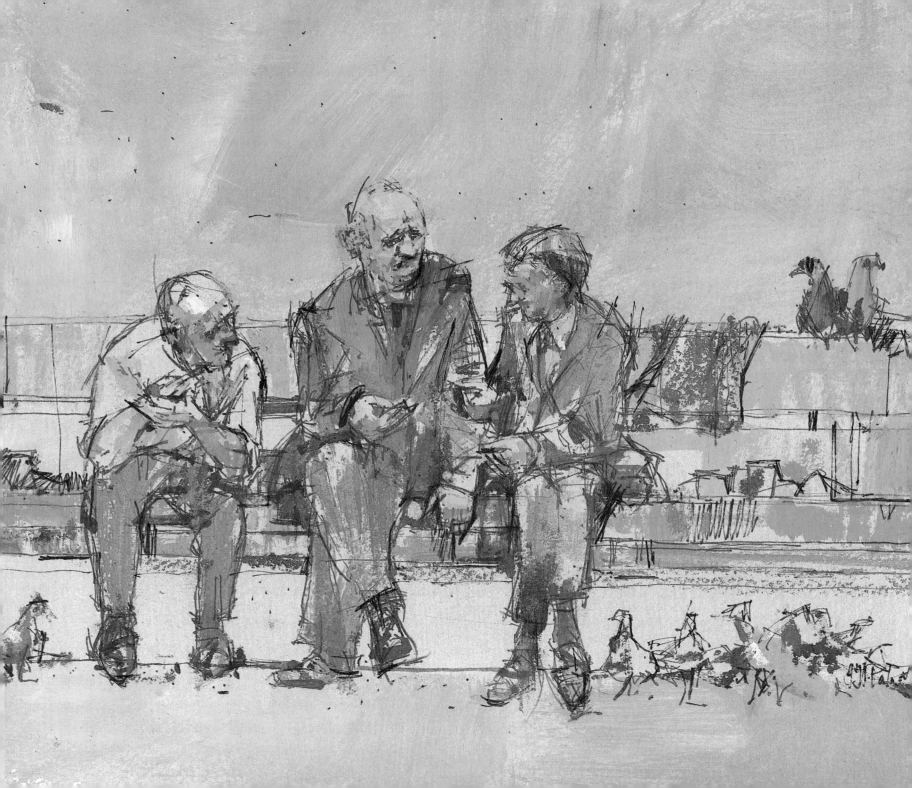

Index